# WILTSHIRE AT WAR

## THROUGH TIME

Henry Buckton

AMBERLEY PUBLISHING

First published 2013

Amberley Publishing
The Hill, Stroud
Gloucestershire, GL5 4EP

www.amberley-books.com

ISBN 978 1 4456 1938 5 (print)
ISBN 978 1 4456 1956 9 (ebook)

British Library Cataloguing in Publication Data.
A catalogue record for this book is available from
the British Library.

Typeset in 9.5pt on 12pt Celeste.
Typesetting by Amberley Publishing.
Printed in the UK.

# Introduction

During the Second World War, Wiltshire was one of the most militarised counties in the country and it is easy to understand why, when you consider that the whole of Salisbury Plain, the Army's premier training ground, lies within its boundaries. But the story of 'Wiltshire at War' is not just about the Army or training. It was here that weapons were developed, tactics were tried and tested, and operations planned and mounted. British, Commonwealth and American troops all made use of the varied facilities. And of course, like every county, the civil population also played their part, working in the factories or fields, or belonging to an organisation such as the Home Guard or the Women's Voluntary Service. In this book we shall be travelling around the county visiting places that have a particular association with the war effort.

We begin in the city of Salisbury where Spitfires were manufactured in requisitioned premises after the bombing of the Supermarine factories in Southampton. Similarly, these iconic aircraft were also produced in Trowbridge and Swindon. We visit many of the county's airfields, including Old Sarum, home of the School of Army Co-operation; High Post, Supermarine's main test flight facility; Boscombe Down, flying from where James Nicholson won Fighter Command's only Victoria Cross of the war; Yatesbury, where radar was developed; Upavon, the centre for flying excellence; Netheravon, where pilots trained for the invasion; and Keevil, Blakehill Farm and Ramsbury, from where airborne forces took off on the eve of D-Day. Wiltshire is also home to several Army towns – Tidworth, Larkhill, Bulford and Warminster – all of which are visited to see what happened there during the war years. Many other towns, including Devizes, Westbury, Chippenham, Malmesbury and Marlborough, were affected by the war in other ways and are also studied in the book. We observe some of the defences that were built along the Kennet and Avon Canal to stop invading forces; the village of Imber on Salisbury Plain, from where all the inhabitants were moved in 1943 in order for American soldiers to train there for fighting in Normandy; Highworth, the gateway to the secret world of the auxiliary units; and Box, near Corsham, where a huge underground city included things such as bomb stores, an aircraft factory, railway locomotive repair sheds and the control rooms of No. 10 Group Fighter Command, which controlled the air space over the South West. These and many other places visited in the book give Wiltshire a rich and diverse wartime landscape.

Henry Buckton

# Acknowledgements

**Photo Credits**

Author: top 11, 38, 40, 60, 61, 62, 64, 77, 85, 93; bottom 4, 5, 6, 7, 8, 10, 11, 12, 13, 15, 22, 27, 30, 31, 32, 34, 36, 37, 38, 39, 40, 45, 46, 50, 52, 53, 55, 57, 61, 62, 64, 66, 67, 68, 75, 76, 77, 78, 80, 85, 90, 92, 93. Author's collection: top 5, 6, 7, 8, 13, 14, 19, 24, 27, 42, 47, 52, 54, 55, 79, 80, 86, 87, 90, 91; bottom 18, 20, 59, 79, 94. Gary Archer, British 1 Airborne Division Living History Association: top 49. www.b24.net: top 92. John Chappell: bottom 19. Doreen Charles: top 50. Peter Clarke: top 84. Vic Damon, 3AD History Foundation: top 51; bottom 51. Evelyn Dancey: bottom 25. Brenda Gower: bottom 21. Hazel Green: top 20, 21. Joyce Hallewell: bottom 17. Tim Hollinger, www.airborne506.org: top 89. Christer Landberg: top 72. Elsie Lewis: top 57, 58; bottom 58. Susan Lindsay, curator, Museum of Army Flying: top 34. A Mckechnie: top 22, 44, 56; bottom 44. V. Mulholland: top 23. Muriel Mundy: top 94, 96. Iain Murray: bottom 16. John Newton, 6th Airborne Division, 9th Parachute Battalion re-enactors: top 39. Grant Paton: bottom 41. Matthew Pellet: bottom 95. Bernard Phillips: top 65; bottom 65. Juha Ritaranta: top 95. Sue Robinson/Bert Bailey: bottom 63. Severnside Aviation Society: top 74, 75. Michael Virtue, Virtue Books: top 9, 10, 12, 15, 16, 17, 18, 25, 28, 29, 30, 31, 32, 33, 35, 36, 37, 41, 43, 45, 46, 48, 59, 63, 66, 67, 68, 70, 71, 73, 76, 78, 82, 83; bottom 9, 29, 33, 35, 42, 48. John Webb: top 26; bottom 26. John Williams: bottom 49. I would also like to thank the following members of the Geograph website for the use of their photographs, licensed for reuse under the Creative Commons License. Ben Brooksbank: top 53, 81, 88; bottom 83, 87, 88. Nick Chipchase: bottom 69. Rick Crowley: bottom 74. Steve Daniels: bottom 56. Vieve Forward: bottom 81, 84. Mike Gentry: bottom 54. Gordon Hatton: bottom 86, 89. Derek Hawkins: top 69; bottom 70; 72, 73. Ben Hollier: bottom 96. Nick Macneill: bottom 91. Bill Nicholls: bottom 60. Maurice Pullin: bottom 23, 71. Mike Searle: bottom 24. Paul Shreeve: bottom 28. Colin Smith: bottom 47. Phil Williams: bottom 14, 43. Ian Yarham: bottom 82.

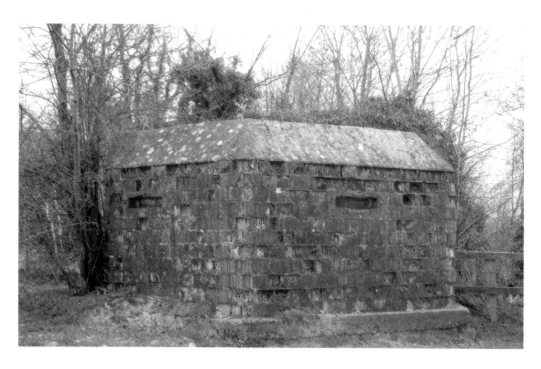

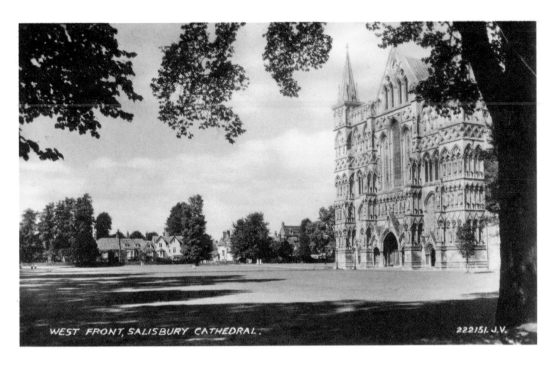

WEST FRONT, SALISBURY CATHEDRAL.      222151. J.V.

## Monuments in Salisbury Cathedral

In Salisbury Cathedral there are various monuments dedicated to the people of the city who gave their lives in the war, including windows designed by Christopher Webb and erected in 1949. These illustrate the various branches of the armed forces and the civil services. A separate window also illustrates the female branches of these services. Other windows, designed by Harry Stammers and erected in 1950, reflect the county's association with the birth of Britain's airborne forces. Above is a pre-war view of the west front of the cathedral with the same scene below today.

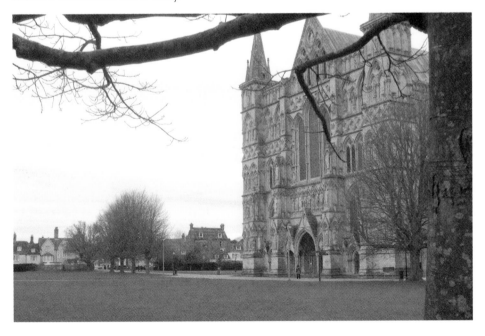

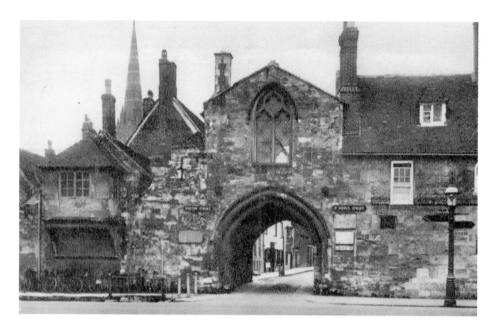

## A Talented Artist

One of the most unusual monuments in the cathedral is a glass prism by the engraver Laurence Whistler dedicated to his brother Rex, who lived in Cathedral Close. It contains an engraving of the cathedral's famous spire. Above and below are contemporary and modern views of St Ann's Gate, which leads into the Close. Rex Whistler is considered to be one of the most talented artists from the interwar years. During the war he served as a tank commander in the Welsh Guards and was killed in July 1944 during Operation *Goodwood*, the attempted break out from the Normandy bridgehead.

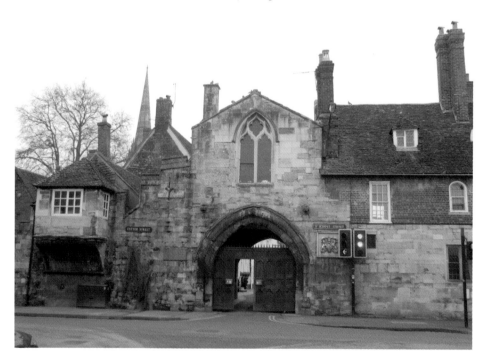

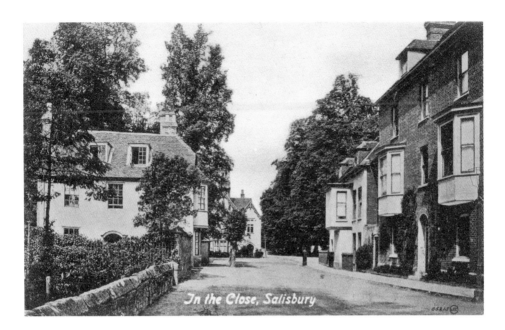

### The Cathedral Close

The Cathedral Close, seen above in an old postcard and below as it appears today, is also coincidentally the setting for The Rifles (Berkshire and Wiltshire) Museum, which is housed in The Wardrobe, a building that was once the bishop's storehouse. The museum tells the story of all of Wiltshire's various regiments, including The Wiltshire Regiment (Duke of Edinburgh's) as the regular battalions were titled during the 1940s. Another notable resident of The Close was former Prime Minister, Sir Edward Heath, who served with the Royal Artillery in Europe during the war.

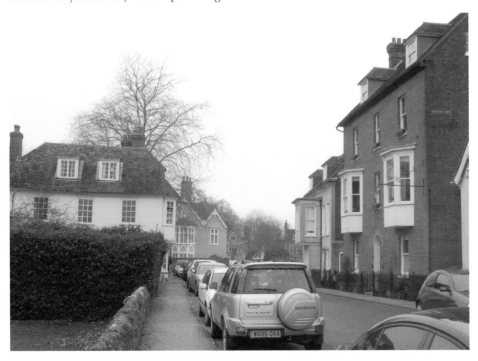

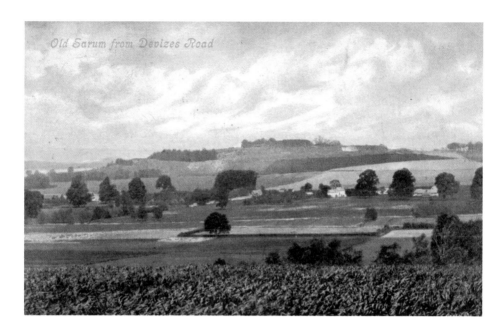

*Old Sarum from Devizes Road*

## Old Sarum

Leaving Salisbury behind and travelling north you will arrive at one of Wiltshire's most distinctive landmarks, the Iron Age hill fort of Old Sarum, seen above in an old postcard and below as it appears today. Just to the east of this is a private airfield on the site that was once known as RAF Old Sarum. By the outbreak of war this had become the School of Army Co-operation. The liaison in question was between the Royal Air Force, which supplied aircraft such as Westland Lysanders and Taylorcraft Austers, and the Army, which supplied pilots and observers to fly in them.

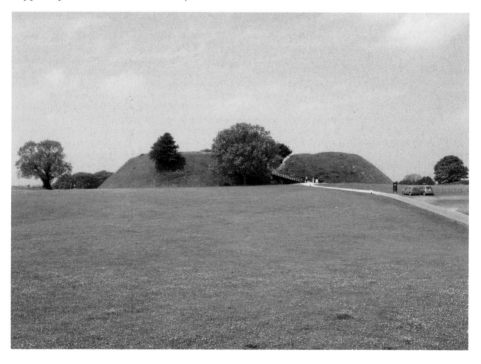

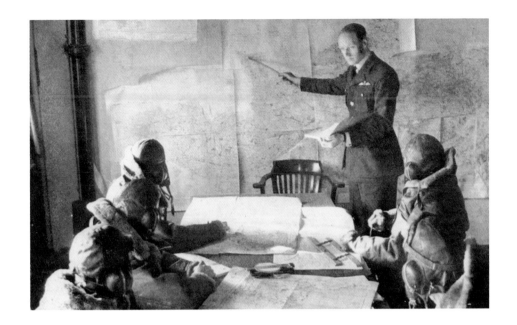

## Army Co-operation

Most pupils at the school were recruited from the Royal Artillery and trained in disciplines such as aerial reconnaissance and air photography. Above and below, Army pilots are taught map reading by an RAF officer, both in the classroom and using a Westland Lysander. They also practised artillery spotting, the idea of which was to position their aircraft close to the guns near the front line. The pilots would fly at very low level, popping up to observe enemy positions to radio their coordinates back to the artillery batteries, so that they could direct their fire on to them.

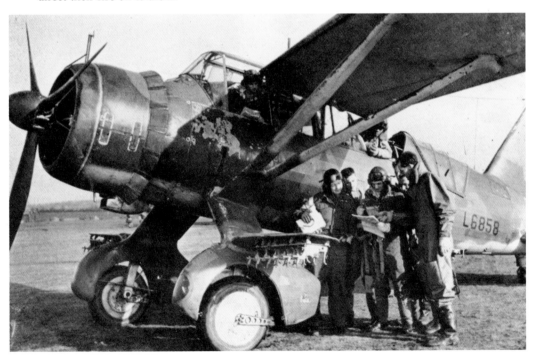

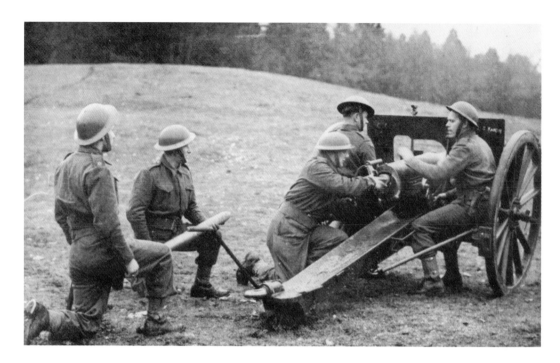

## Artillery Spotting

The technique of artillery spotting was developed between the wars by two Royal Artillery officers, Captain Jack Parham and Captain Henry Bazeley. The open country north of Stonehenge was perfect for this training, as there was plenty of space for the aircraft to work closely with the gun teams (*above*). In time, this led to the formation of units called Air Observation Post, or AOP squadrons, in which the pilots were drawn from the Army and the ground staff from the Army and the RAF. Below we see the airfield in the distance today, photographed from the top of the hill fort.

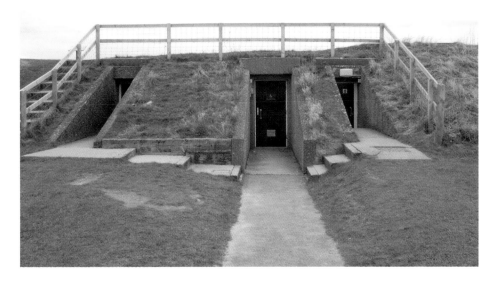

## AOP Squadrons

651 Squadron, which was formed at Old Sarum in August 1941, was commanded by Henry Bazeley himself and was the first of the AOP units to see active service when it was deployed to North Africa. In total, sixteen AOP squadrons were formed during the war, ten of them at Old Sarum. At the hill fort itself, an anti-aircraft battery looked out across the airfield and city. It was situated in the current visitor's car park, and the toilets seen above now occupy the air-raid shelter which was attached to it. The bunker pictured below formed part of the airfield's defences against invaders.

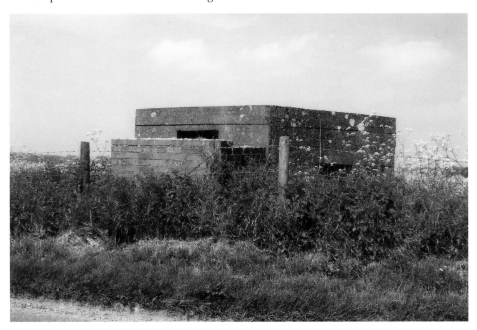

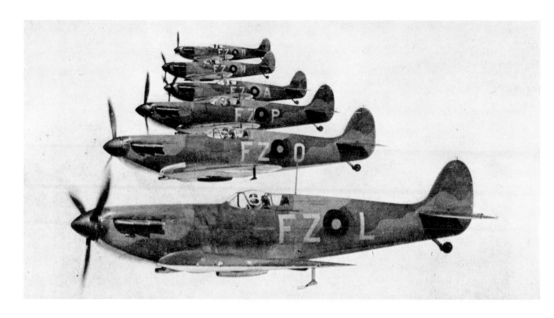

## High Post

Further north towards Amesbury is a place called High Post, where a range of businesses now occupy the site of what used to be another important airbase. The aerodrome here at High Post had varied uses, most significantly as an assembly and testing station for Supermarine Spitfires. At the start of the war a large proportion of Spitfire fuselages were manufactured in Southampton. In a bid to stop their production, the Luftwaffe bombed the factories that made them in a series of raids in September 1940. Above we see a flight of Spitfires and below one of the old hangars at High Post today.

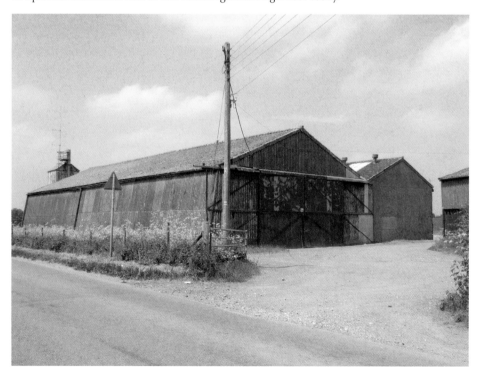

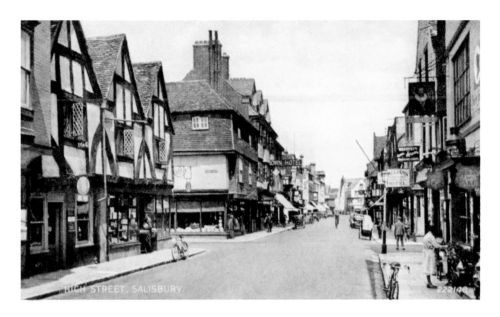

## Spitfire Production

Because of the bombing, Supermarine dispersed Spitfire production around the area and various premises were requisitioned in Salisbury, the High Street of which is seen above in the 1930s and below today. Three of these sites were in Castle Street, including the depot of the Wiltshire & Dorset Bus Company. The components made at these units were delivered to a hangar at High Post for assembly. Six aircraft a week were completed here and then subjected to a rigorous series of test flights at the hands of Supermarine's chief test pilot Jeffrey Quill, or another member of his staff.

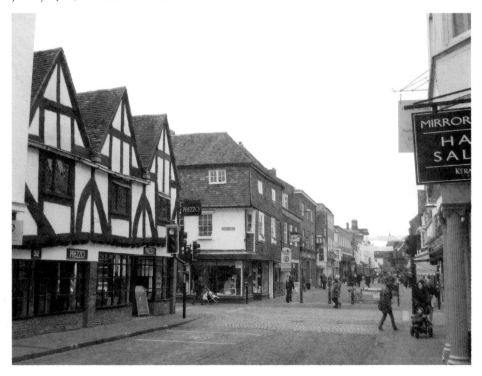

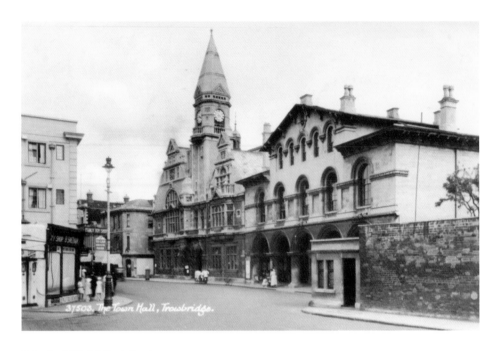

### Principal Flight Test Centre

There was a similar set-up at Trowbridge, with Spitfire components manufactured in requisitioned premises around the town and assembled in a hangar at RAF Keevil. Above we see Trowbridge town hall during the period in question and below as it appears today. So although High Post was not the only place assembling and testing these aircraft, in March 1944 it became Supermarine's principal flight test centre, at which time the runway was extended. Today there is little evidence of the airfield itself but there are still many signs of its former military career in the shape of buildings.

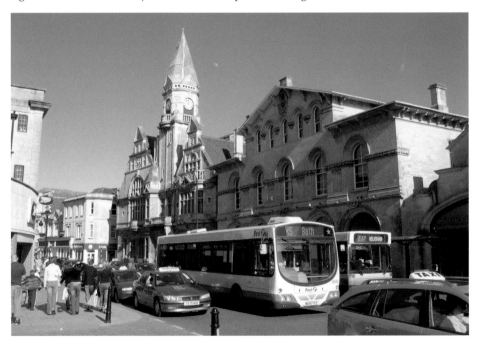

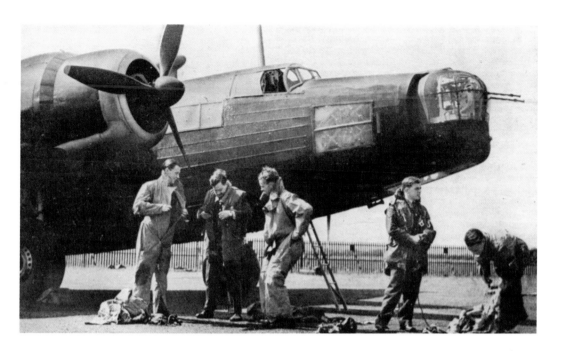

### Experimental Establishment

A number of airfields in the county are still in use with the RAF today, including Boscombe Down to the east of Amesbury. In September 1939 this was the home of the Aeroplane and Armament Experimental Establishment, where both aircraft and their weapons were evaluated. The many aircraft that underwent trials at Boscombe included bombers such as the Vickers Wellington (*above*) and the Avro Lancaster, as well as the first British production jet fighter, the Gloster Meteor. In the photograph below, Boscombe Down is seen from a vantage point along the A303.

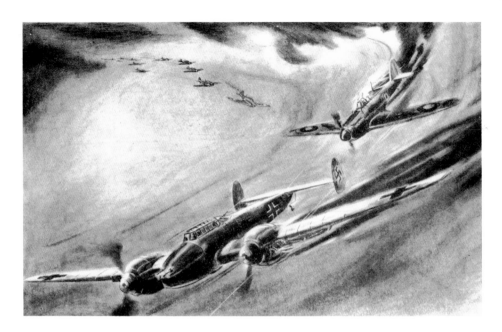

**For Conspicuous Gallantry**

All three of the famous bombs designed by Barnes Wallis were partially developed at Boscombe Down: Upkeep, better known as the bouncing bomb, Grand Slam and Tallboy (below). During the Battle of Britain, No. 249 fighter squadron was based at the airfield to help guard the area against enemy attack. As a result of his extreme valour on 16 August 1940 while flying from Boscombe Down, Flight Lieutenant James Nicholson was awarded Fighter Command's only Victoria Cross of the Second World War. Above is a contemporary drawing of the action that led to the award.

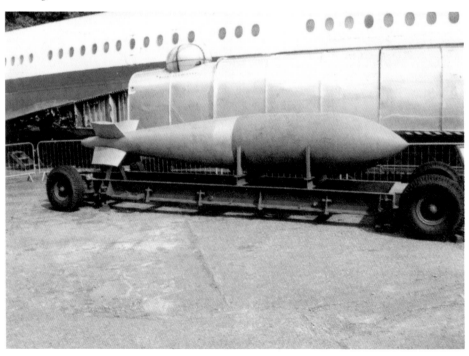

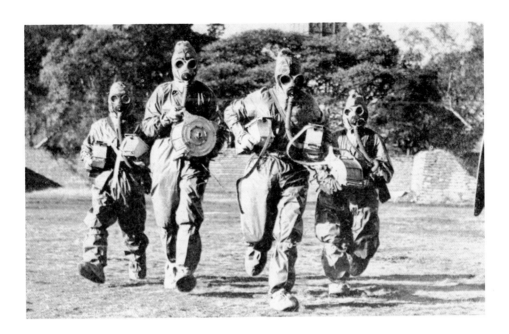

## Preparing for Gas Attacks

Porton Down was another highly secretive research establishment. In fear of the Germans using mustard gas or other chemical agents, scientists here were given the job of developing the gas masks that were issued to every serviceman and civilian. The adult mask was made of black rubber and was fitted with a canister containing charcoal, which had the ability to soak up any poisons. Above we see personnel undergoing exercises while wearing gas masks and decontamination suits. Children had their own gas mask, known as a Mickey Mouse to encourage their use, as seen below.

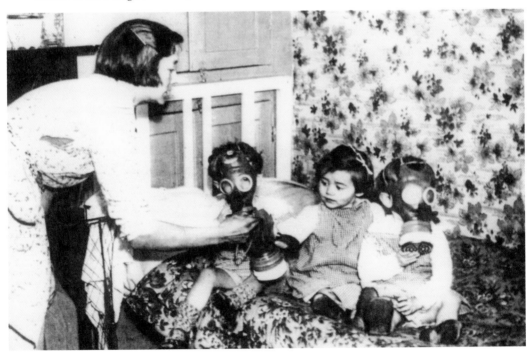

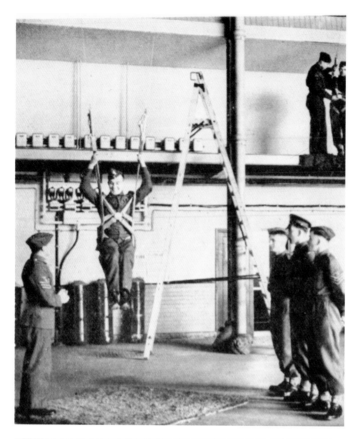

## Formation of the Parachute Regiment

In June 1940 following the success of German paratroopers, Winston Churchill gave the order to raise a compliment of 5,000 British airborne troops. This led to the formation of the 1st Battalion the Parachute Regiment, based at Kiwi Barracks in Bulford under the command of Lieutenant Colonel Ernest Down. Bulford was a garrison town where the shops and facilities had evolved around the military base. In the photograph above we see airborne recruits undergoing rudimentary parachute training, while the pre-war postcard below shows something of the early sprawl of Bulford Camp.

A. 32486. SALISBURY: BULFORD CAMP. S.E.

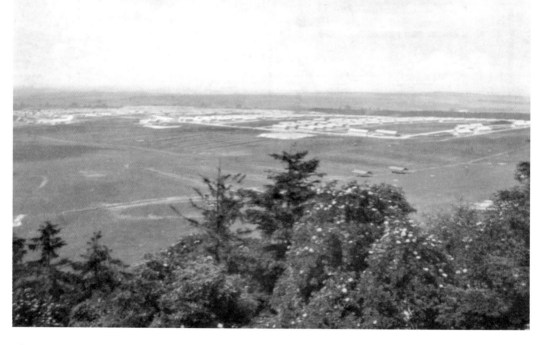

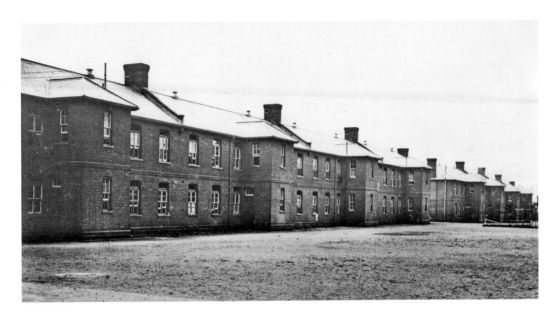

## A Garrison Town

Another of Wiltshire's garrison towns is Tidworth, where the barracks have been home to a long line of British Army regiments ever since they were constructed in the early 1900s. However, when America entered the war the whole military make-up of the area was set to change, as Tidworth was established as the headquarters of the United States II Corps under the command of General Mark Wayne Clark. From June 1942 thousands of GIs arrived to train for the liberation of occupied Europe. Above is a pre-war view of Assaye Barracks in Tidworth and below the Queen's Own Hussars parade at Candahar Barracks in the 1960s.

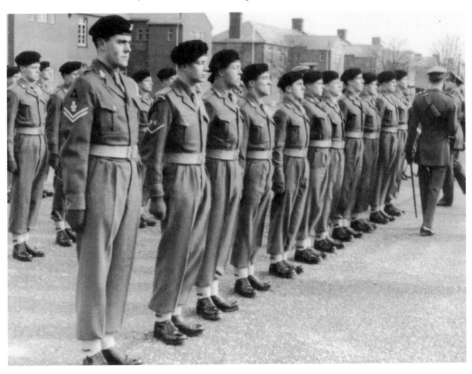

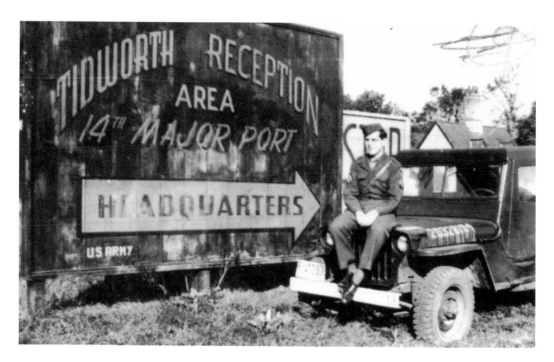

## Arrival of the Americans

The first Americans to train in Tidworth were the 1st Infantry Division under Major General Terry Allen. His second in command was the son of the president, Brigadier Teddy Roosevelt Junior. Next to arrive was the 29th Infantry Division under General Charles Gerhardt. On D-Day, these two divisions, together with the 4th Infantry Division, would provide the main assault troops for the landings on Utah and Omaha beaches. Above, an American soldier sits on his jeep at the Tidworth reception area, while below we have a view of Matthew Barracks in Tidworth, taken just after the war.

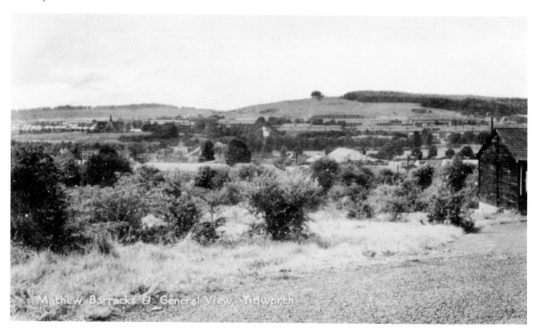

Mathew Barracks & General View, Tidworth

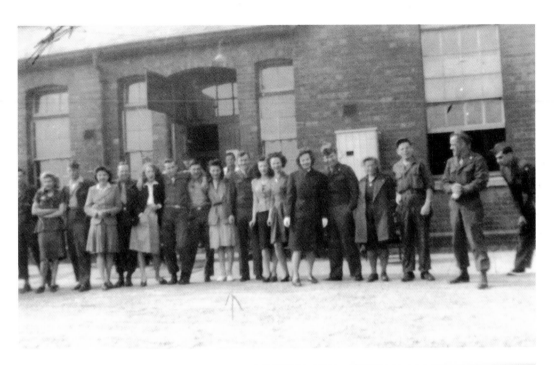

## The American Red Cross

Tedworth House near Tidworth became an American Red Cross club, managed by the wife of Brigadier Roosevelt. It was very popular with its doughnut-making machine and hamburger grill. Weekly dances were held here, which were a powerful draw for local women. It is claimed that the hokey cokey was introduced into Britain here in 1943. The Cadre Club (*above*) was another spot in Tidworth where the Red Cross would sometimes organise dances. The picture on the right shows the American Red Cross Clubmobile that supplied troops on Salisbury Plain with coffee and doughnuts during training.

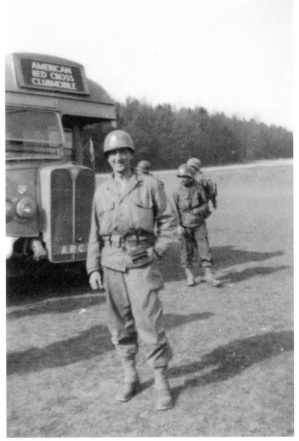

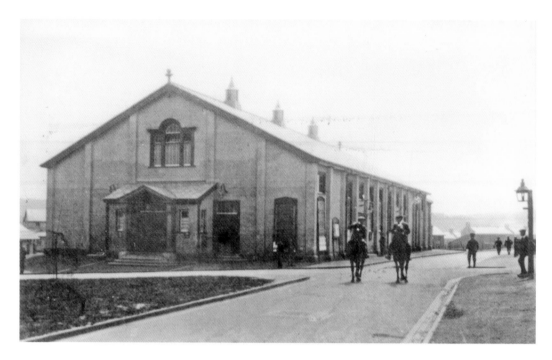

## Leisure Facilities

While the Americans were in Tidworth, James Cagney and Bob Hope were among the entertainers who performed at the garrison theatre, which can be seen before the war in the photograph above. After the war, both Tidworth and nearby Perham Down became transit camps for ladies who had married American servicemen and were departing for the United States. From these camps, 640 GI brides were processed along with 176 infants. The building in the photograph below is the Oval athletics and football stadium, which forms part of the modern recreational facilities at the garrison.

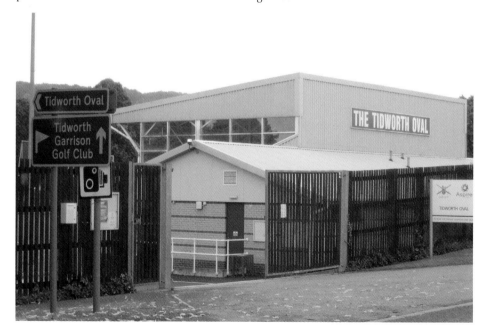

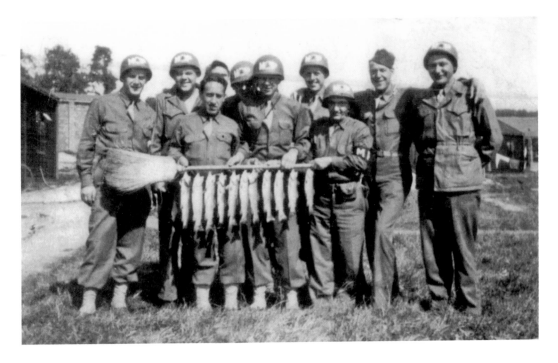

## Gone Fishing

Americans were stationed all over Wiltshire and the photograph above is of troops camped at Upton Lovell with a haul of trout. It came to light when an exhibition was set up for the millennium at nearby Corton. It was donated by David Fostick, whose mother had told him that the soldier in the picture without a hat was Corporal Dippary, a regular visitor to her family home. The River Wylye was dredged during the war to make it too deep for tanks to cross in case of invasion. Below is a photograph of the Wylye today between Upton Lovell and Corton – I wonder if the fishing is still as good?

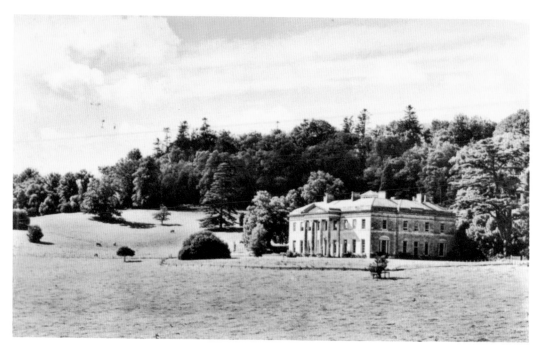

## Social Housing

Another village to experience a considerable influx of American troops was Dinton, where some 1,800 men were stationed in readiness for D-Day. They were mainly accommodated in tents and Nissen huts erected in Dinton Park, the country estate that surrounds Phillips House and which can be seen above in a pre-war postcard and below as it remains today. Some of the Nissen huts were used after the war to house local people but these were later replaced by newly built social houses. However, various wartime huts and buildings can still been found on local farmland.

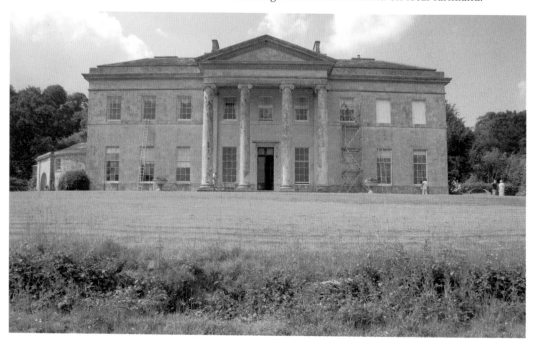

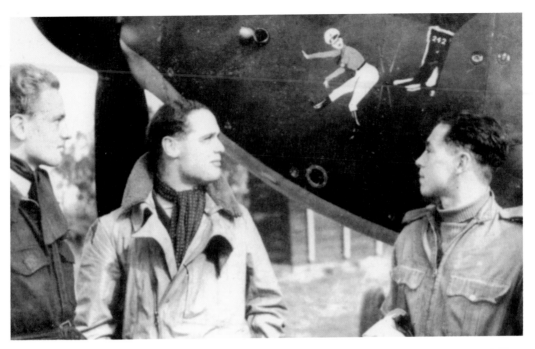

### Centre of Excellence

The Central School of the RAF at Upavon was regarded as a centre of excellence, where qualified pilots perfected their skills, flying nearly every type of aircraft in service. The school also reassessed the suitability of men who had already served in the RAF. Perhaps the most famous was Douglas Bader (*above*, centre) who had lost both of his legs in a flying accident before the war. He learnt to walk with artificial limbs and was reassessed at Upavon as 'exceptional'. On the right, Viola Cove is seen in the uniform of a WAAF instrument repairer based at Upavon working on various aircraft.

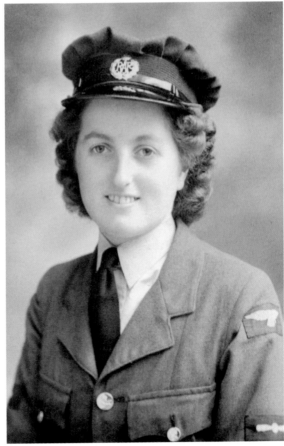

## A Quiet Posting

The Central Flying School also utilised a number of smaller satellite airfields in the county such as New Zealand Farm, which was opened in October 1940 on Cheverell Down. Its main use was for night-flying training. It was a relatively quiet posting although a Heinkel He III did attack the site in April 1941. It dropped ten bombs but luckily there were no casualties. During the war it was used by various schools, and aircraft flown from here included Miles Masters and Magisters. Above we see the mess halls and below the inside of an accommodation block, photographed shortly after the war.

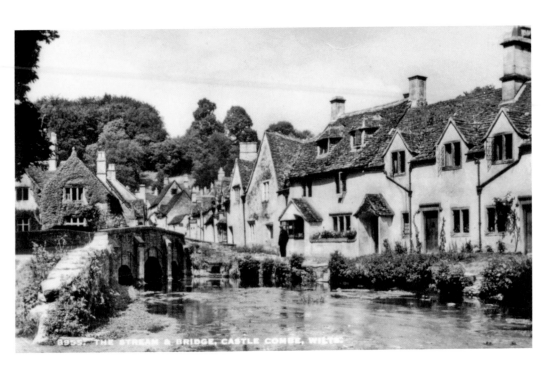

## Wartime Expansion

But with the wartime expansion of the RAF the Central Flying School was moved to Little Rissington in Gloucestershire and the facilities at Upavon were used to train flying instructors, who would then be posted to one of the many flying schools that were opening around the country. One such school was at Clyffe Pypard near Royal Wootton Bassett, and another was at Castle Combe on the site that is now occupied by the motor-racing circuit. Above and below are contemporary and modern views of Castle Combe village itself, arguably one of the prettiest in Britain.

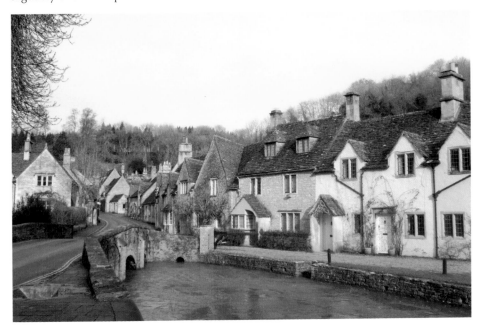

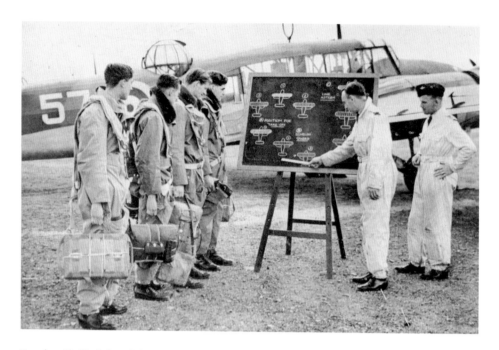

## Empire Air Training Scheme

Another flying school was established at RAF Hullavington between Chippenham and Malmesbury, now Buckley Barracks. Below is a surviving hangar at the site. At the various training schools, students were taught to fly at every level, from absolute beginners operating Tiger Moths to handling front-line aircraft, such as Hawker Hurricanes and Supermarine Spitfires. These students came from all around the world. Some were RAF entrants, while others came from the Commonwealth as part of the Empire Air Training Scheme. Above, trainee pilots from the RAF are shown how to fly in formation.

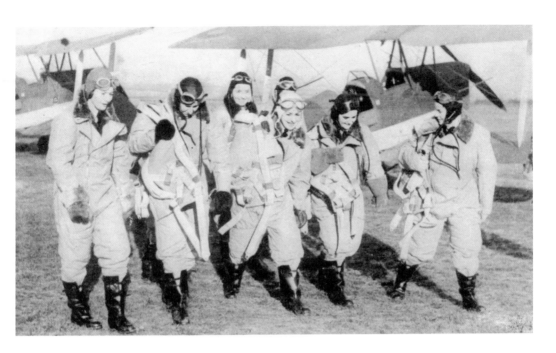

## Air Transport Auxiliary

Civilian pilots of the Air Transport Auxiliary, including many women (*above* and *below*), were also trained at Upavon. Their job was to ferry new aircraft from testing facilities, such as High Post, and take them to an RAF maintenance unit where they were stored before being sent to an operational squadron. Once again, Wiltshire was home to several of these MUs, most particularly RAF Lyneham, which at one time became a dedicated storage facility for Supermarine Spitfires. Later, it was used to assemble and store Hamilcar gliders in the build-up to the invasion of Europe.

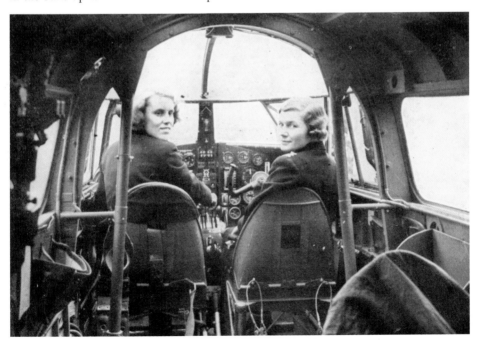

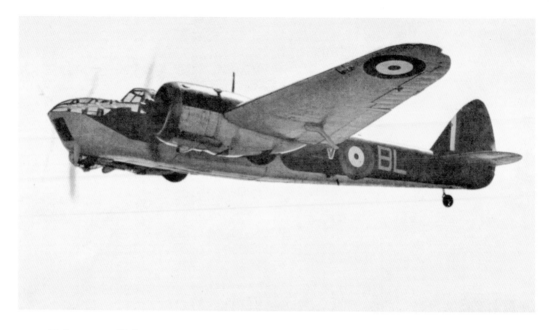

### Maintenance Units

Another maintenance unit was situated at RAF Wroughton on the northern side of the Marlborough Downs. Aircraft that were regularly kept in storage here included Hawker Hurricanes and Bristol Blenheims (*above*). A large number of Airspeed Horsa gliders were also assembled and stored here prior to the invasion. Below is an old guardhouse at an entrance to the site today. Some of the remaining buildings are now used by the Science Museum in London to store aircraft and other large exhibits. Wroughton was also the location of the RAF general hospital between 1941 and 1996.

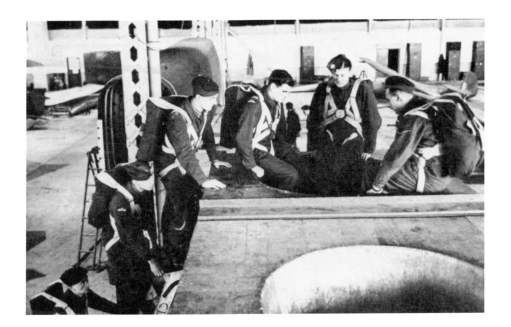

## RAF Netheravon

Earlier we saw how the 1st Battalion the Parachute Regiment was based in Bulford. Above, wartime paratroopers learn how to exit from an aircraft at the training base. But these men would of course require real aircraft both to train with and eventually to carry them in to operations. It was therefore imperative that a suitable airfield was found close to Bulford; this would prove to be RAF Netheravon. The headstone below, in the military cemetery between Netheravon and Durrington, shows the badge of the Glider Pilot Regiment, part of the force that would carry the paratroopers into battle.

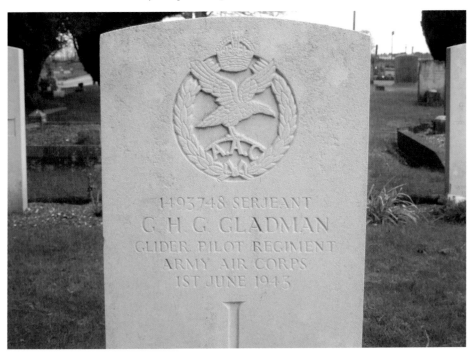

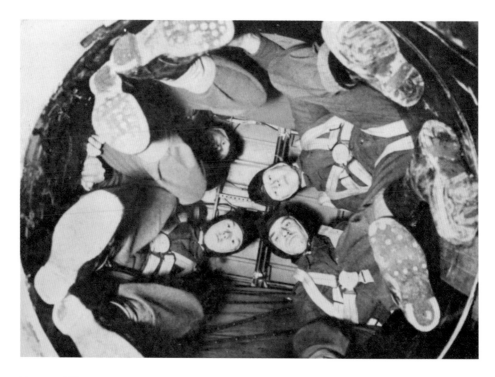

### Syrencot House

Collectively, the paratroopers and the RAF units that would fly them into battle constituted the 1st Airborne Division, commanded by Major General Frederick 'Boy' Browning from his headquarters at Syrencot House about 2 miles north of Bulford. Later, it was also the headquarters of the 6th Airborne Division, under Major General Richard Gale. It was from here that the airborne assault on D-Day to secure the left flank of the Allied invasion front was meticulously planned and mounted. Above we see further paratroopers under training, and below the driveway to Syrencot House today.

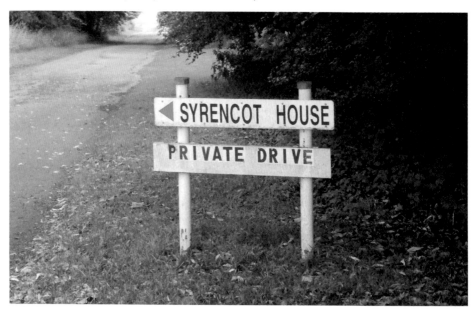

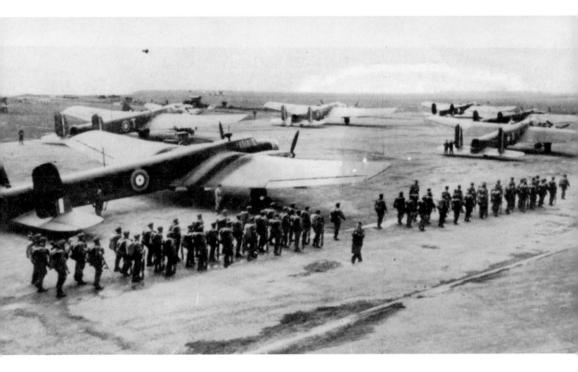

**Flying into Battle**

The job of transporting the paratroopers to the battlefield was given to No. 38 Group and No. 46 Group of Army Co-operation Command of the Royal Air Force, both of which were headquartered at RAF Netheravon. During training exercises on Salisbury Plain, converted Whitworth Whitley bombers were used to ferry the men to their drop zones while Hawker Hector biplanes were employed to tow the Hotspur gliders. Above, paratroopers are seen boarding Whitleys during an exercise at Netheravon, while below members of the RAF ground crews are seen working on one of the aircraft.

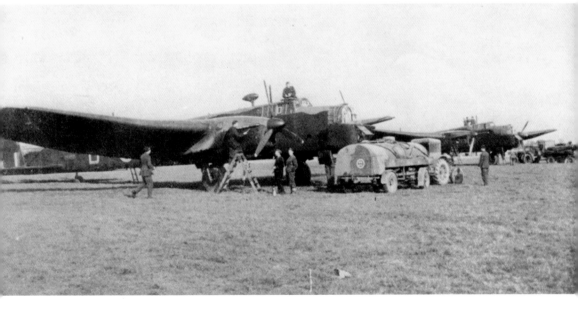

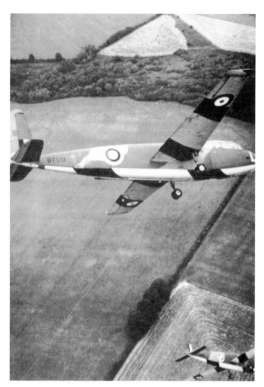

### Training Glider Pilots

Although the personnel of nos 38 and 46 groups were from the RAF, the men who piloted the gliders were drawn from the Army. They belonged to the Glider Pilot Regiment, which was formed in December 1941. The reason for this was that once they had landed their gliders on the battlefield, their job as aviators was effectively over. They would then have to integrate into the troops on the ground as infantrymen. A training depot for the regiment was established at Tilshead, now the site of Westdown Camp. On the left we see a Hotspur glider flying over Salisbury Plain, and below the Glider Pilot Regiment window in Salisbury Cathedral.

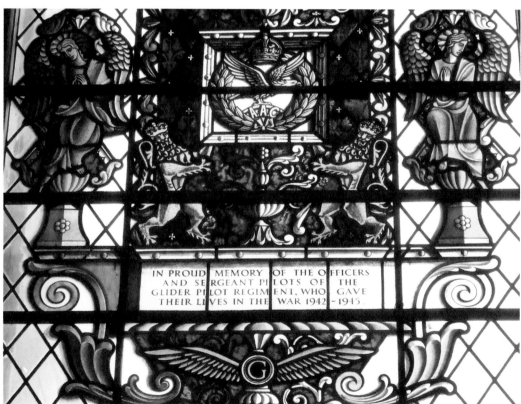

IN PROUD MEMORY OF THE OFFICERS AND SERGEANT PILOTS OF THE GLIDER PILOT REGIMENT, WHO GAVE THEIR LIVES IN THE WAR 1942-1945.

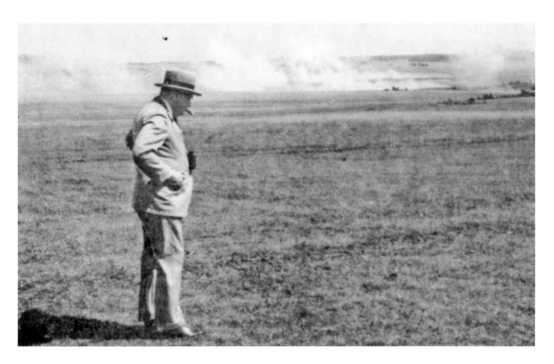

## Suitably Impressed

On 16 April 1942, Winston Churchill was treated to a demonstration at Netheravon to see how his plans were progressing. During a full-scale exercise, troops jumped out of twelve Whitleys, while others were towed to the landing zone in Hotspur gliders. Although the demonstration suffered from a number of setbacks, Churchill was said to be suitably impressed with the results, and the programme continued. Above, the Prime Minister is pictured on Salisbury Plain watching an unspecified military exercise, while below the king and queen are also seen observing armoured manoeuvres on the plain.

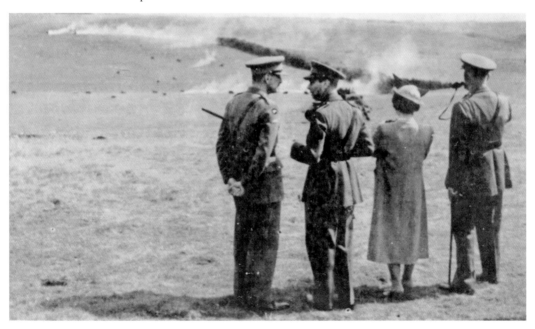

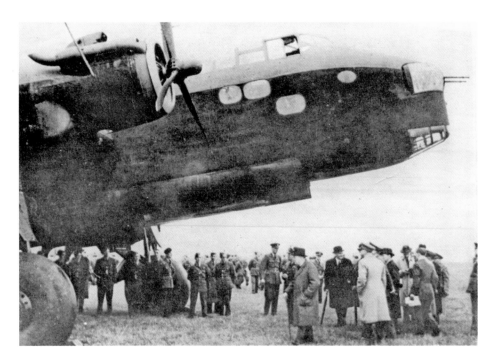

### Stirling Work at RAF Keevil

All this training eventually led to D-Day and, as far as the airborne assault was concerned, Wiltshire still had a major role to play. In preparation for D-Day the squadrons of nos 38 and 46 groups were dispersed around a number of airfields in southern England, including two in Wiltshire: Keevil, near Trowbridge, and Blakehill Farm, near Cricklade. At Keevil two squadrons had been equipped with Short Stirling bombers adapted for carrying paratroopers and pulling Horsa gliders, as seen above being inspected by the Prime Minister. Below are some of the old airfield buildings at Keevil today.

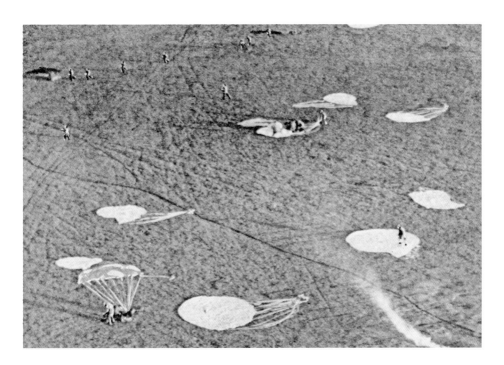

## Pushing the Enemy Back

It was the responsibility of the squadrons at Keevil to ferry soldiers of the 6th Airborne Division to their objectives of capturing and holding the bridges across the Caen Canal and River Orne, in order to protect the eastern flank of the main invasion force as it landed by sea. Just before midnight on 5 June 1944, forty-six Stirlings with gliders took off from Keevil with 806 paratroopers on board. These troops managed to push the Germans back to win a bloody but significant victory. Above, paratroopers are seen on the ground, while the abandoned garage near the airfield seen below still has wartime petrol pumps *in situ*.

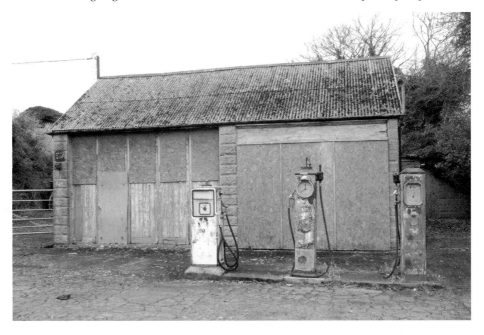

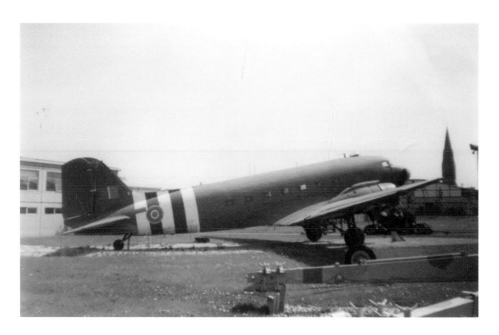

## Down on the Farm

At Blakehill Farm No. 233 Squadron had been supplied with Douglas C-47 Dakotas such as the example seen above, now on exhibit in Aldershot. Their job was to carry the 9th Parachute Battalion to their objective of disabling the Merville Battery, which threatened the left flank of the landing beaches. Due to errors during the glider landing, 9th Para put the guns out of action with roughly one quarter of the 600 men they had set out with. The memorial below at Blakehill Farm is dedicated to the personnel of 233 Squadron and the glider pilots who operated from here during the D-Day operation.

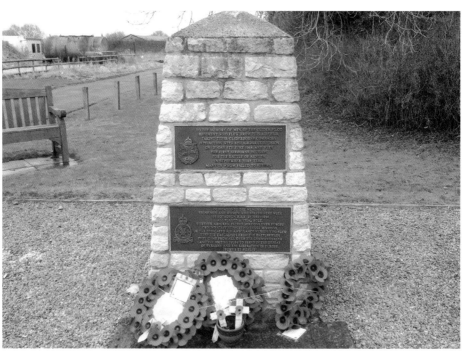

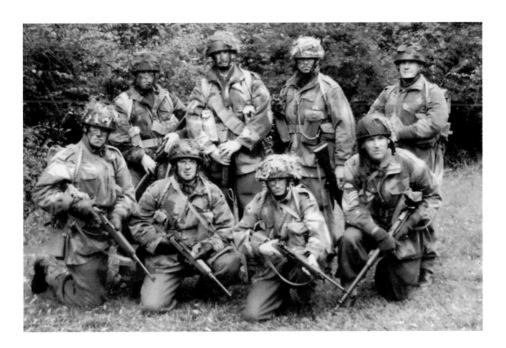

## Operation *Market Garden*

In September 1944, the squadrons at Keevil and Blakehill Farm were given the even bigger task of helping to carry the 1st Airborne Division into Holland for the ill-fated Operation *Market Garden*. The men would be dropped 60 miles behind enemy lines to capture and hold the bridge across the Rhine at Arnhem. At the same time, but setting out from other airfields, two American airborne divisions also landed in Holland. Above, re-enactors demonstrate the uniforms and equipment of the 9th Parachute Battalion, while below we see a surviving wartime construction at Blakehill Farm.

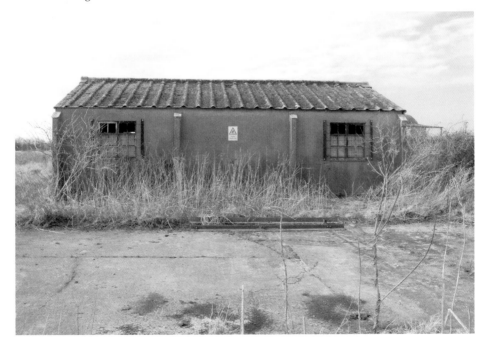

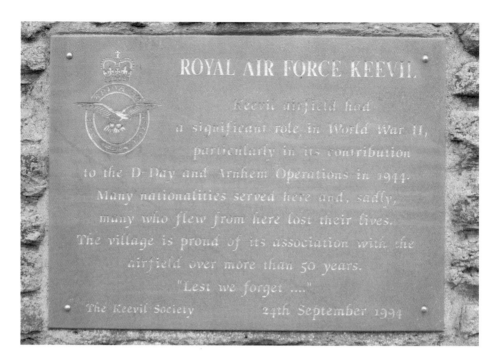

ROYAL AIR FORCE KEEVIL

Keevil airfield had
a significant role in World War II,
particularly in its contribution
to the D-Day and Arnhem Operations in 1944.
Many nationalities served here and, sadly,
many who flew from here lost their lives.
The village is proud of its association with the
airfield over more than 50 years.

"Lest we forget ...."

The Keevil Society          24th September 1994

## The Bridge Too Far

Of the 10,095 troops that went to Arnhem, less than 3,000 would make it back. Operation *Market Garden* was one of the costliest disasters of the war for the British, and the bridge at Arnhem, which the Parachute Regiment fought over for nine gruelling days, became known as 'The Bridge Too Far'. Above is a memorial plaque in Keevil village, and below is a display board at Blakehill Farm, which is now a nature reserve. The runways were torn up in the 1970s, to provide hardcore for the building of the M4. It is now a haven for wildlife and the only flying is done by birds or insects.

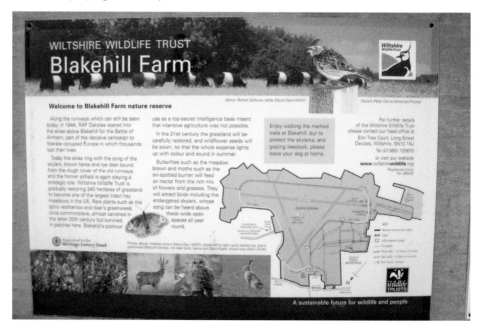

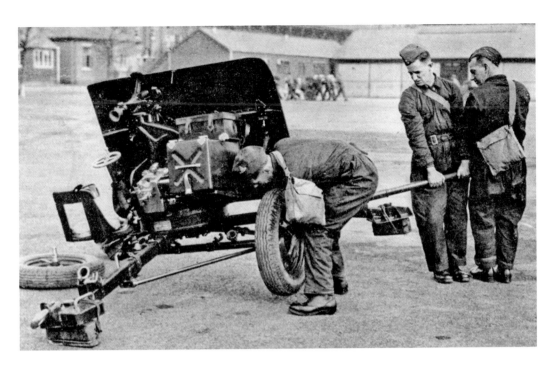

### School of Artillery

Wiltshire is an ancient county and just to the north of its most famous monument, Stonehenge, is another of its garrison towns, Larkhill. The Army was first attracted here in 1899, as it found the downland perfect for practising with long-range weapons, and Larkhill has since become synonymous with the Royal Artillery. The School of Artillery at Larkhill opened in 1920. During the war the soldiers who passed through it were mainly either British or other Commonwealth gunners attending its varied courses (*above*). Below is a picture of the officers' mess taken in around 1960.

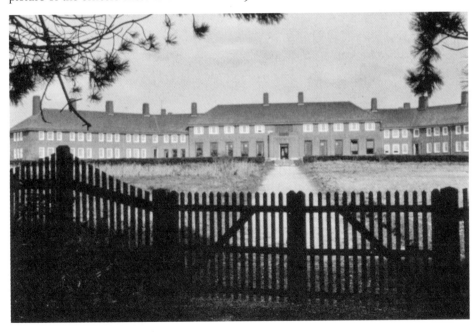

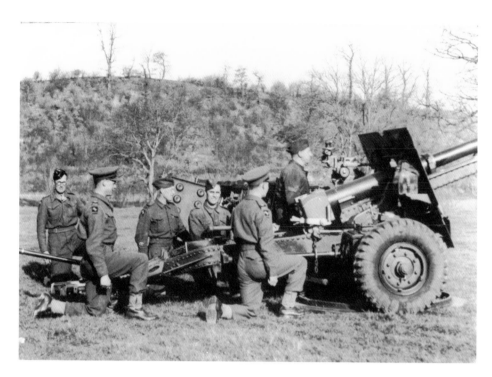

### A Range of Guns

The students at the School of Artillery were given instruction in how to operate the 25-pounder gun-howitzer (*above*). This was the standard field artillery weapon of the day and used in every theatre of the war. But there was also instruction with a range of larger guns for both medium and heavy artillery, such as the weapon seen below. Aware of the garrison's importance, it was occasionally targeted by the Germans. The worst incident took place on 17 January 1941, when bombs fell as a group of new recruits slept in their huts. Nineteen people were killed and many more injured.

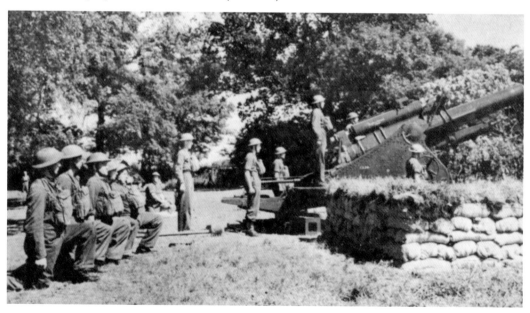

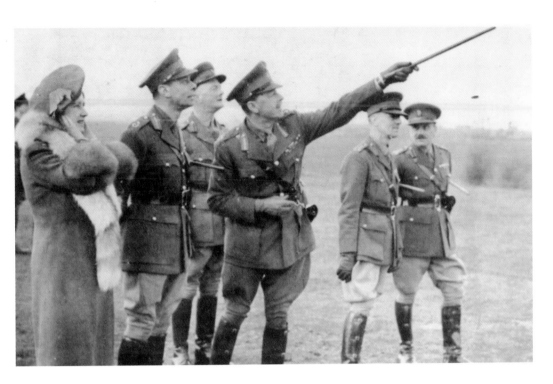

## A Royal Visit

During a first aid class on one course in 1940, an instructing officer was reported to have said 'he'll be no good in action' after one of his cadets fainted. The man was George Ward Gunn, who within eighteen months had won the Victoria Cross in North Africa. The School of Artillery hosted its first official royal visit on 3 April 1941, when King George VI and Queen Elizabeth enjoyed a demonstration on the ranges, and it has continued to enjoy close royal patronage ever since. Above, the queen is seen shielding her ears from the roar of the guns. Below we see the garrison church today.

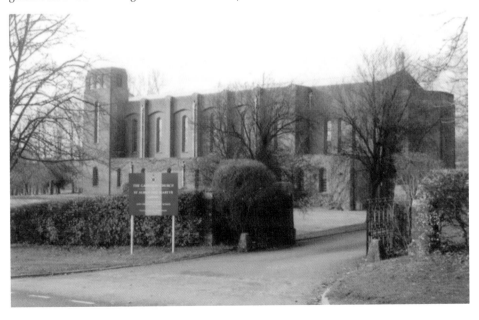

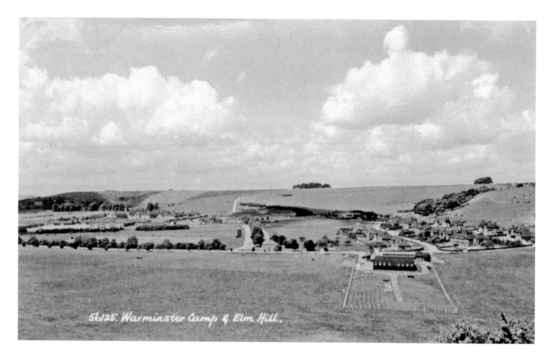

5L125. Warminster Camp & Elm Hill.

## Ideal for Tank Warfare

It wasn't just the Royal Artillery that recognised the advantages of using Wiltshire's open spaces. By the start of the war a couple of garrisons had become almost totally dedicated to tank warfare, most notably Warminster Camp, seen above and below just before the outbreak of hostilities. The first barracks were opened here in 1938, their first occupants being the 3rd Battalion the Royal Tank Corps. On the outbreak of war, the camp became a training establishment for the Royal Armoured Corps. Today the Royal Tank Regiment and Royal Engineers Workshops can be found at Sack Hill.

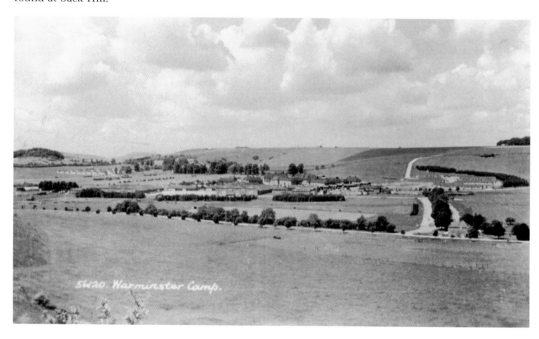

5W20. Warminster Camp.

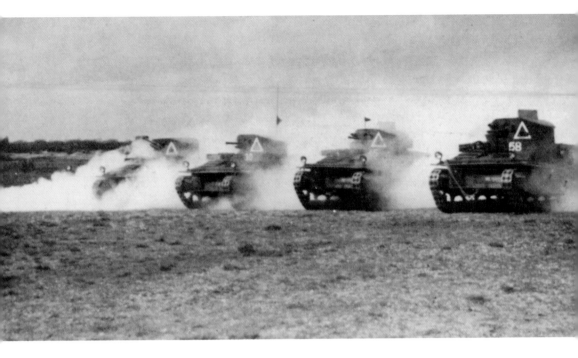

## Large-Scale Manoeuvres

The surrounding countryside had been earmarked for large-scale manoeuvres, in which entire divisions learnt to work and fight together in preparation for going overseas, as seen above. First to arrive was the Guards Armoured Division, formed in 1941. Not only were the facilities at Warminster Camp itself used to accommodate these troops, but a number of smaller camps were set up in outlying villages, such as Longbridge Deverill, Sutton Veny, Bishopstrow and the Codfords. The Woolstore Theatre in Codford St Peter, seen below today, was requisitioned as a mess hall.

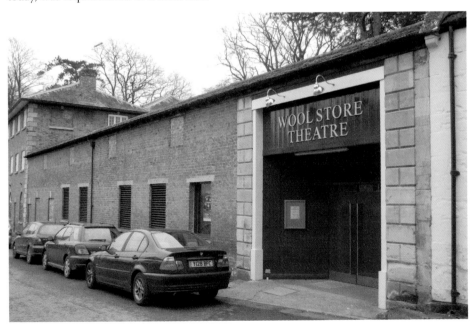

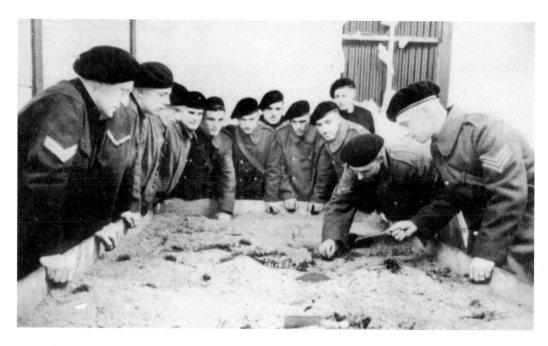

### The Way Ahead

In 1943 it was the turn of the 42nd Armoured Division to use Warminster Camp and its satellites. While stationed there they took part in an Army recruiting film entitled *The Way Ahead*, which was commissioned by the War Office and starred David Niven, who during the war was an actual Lieutenant Colonel in the Rifle Brigade. Coincidentally Niven had married the actress Primula Rollo, who was serving in the Women's Auxiliary Air Force at the time, in St Nicholas church at Huish near Pewsey (*below*) on 21 September 1940. Above, tank soldiers are seen undergoing training in the classroom.

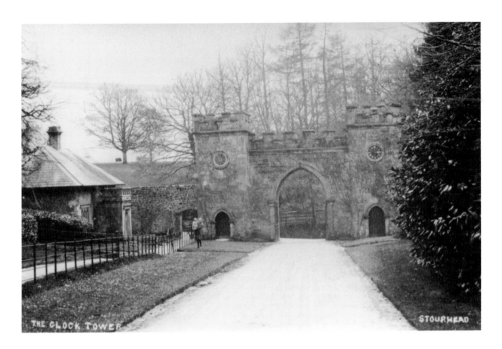

### Etched in Time

While serving in Wiltshire, David Niven also stayed at Stourhead, where officers were accommodated in the mansion while other ranks camped in the grounds. Above and below are contemporary and modern views of the gatehouse to the estate. Visitors to the Spread Eagle Inn in Stourton can still apparently see what are claimed to be the names of Niven and his wife etched into one of the windows. The owner of the estate also gave permission for an airfield to be built on his land; it was then used between 1941 and 1945 by the British, Canadian and New Zealand air forces.

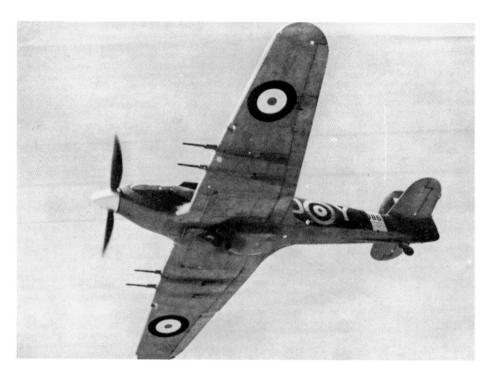

### Deadly Demonstration

On 13 April 1942, the downs near Warminster were the setting for one of the most tragic military accidents of the war. During a demonstration of the deadly effect that Hawker Hurricanes armed with cannons could have on enemy troops (*above*), twenty-five military personnel were killed and another seventy-one injured, many of whom were high-ranking officers. An inexperienced pilot mistook a crowd of observers for a column of dummy soldiers and fired directly into them. The demonstration was a dress rehearsal for a visit by Winston Churchill that went ahead as planned three days later (*below*).

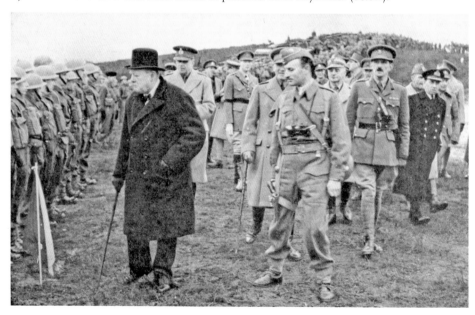

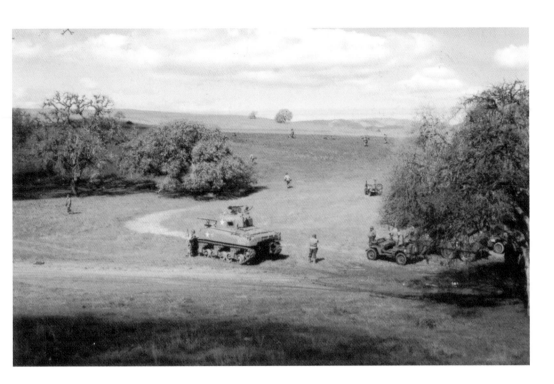

## A Remote Rural Idyll

In September 1943 it was the turn of the Americans to occupy Warminster Camp, when the United States 3rd Armored Division moved into the area to begin their pre-invasion training (*above*). The reason of course why Warminster had grown into a garrison town was because of the training opportunities that existed on the nearby downs for both tanks and artillery. Right at the heart of this vast training area was a remote little village called Imber, pictured below during the 1930s. It was very much a rural idyll where most people either worked for the local gentry or in agriculture.

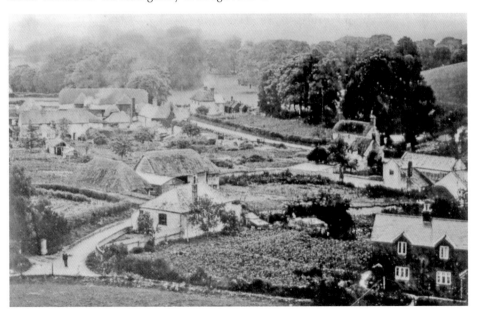

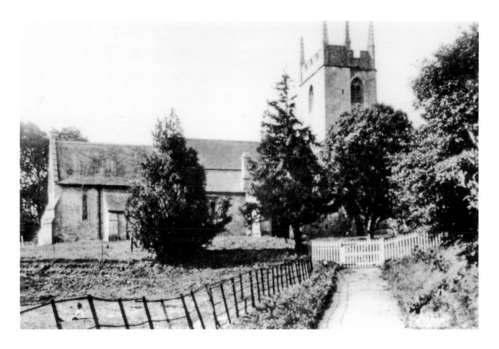

## Purchasing the Village

Before the war the government purchased every property in Imber, except those belonging to the Church, and rented them back to the villagers. In November 1943 it was announced that the Americans needed the village to train their soldiers for street fighting in Normandy, so the residents were moved out. It is claimed that the Army promised that once the war was over they would be able to return but this did not happen and no legally binding document has ever been produced to support the claim. Above is a contemporary view of St Giles church, while below we see a roadblock at the edge of the training area near to the village.

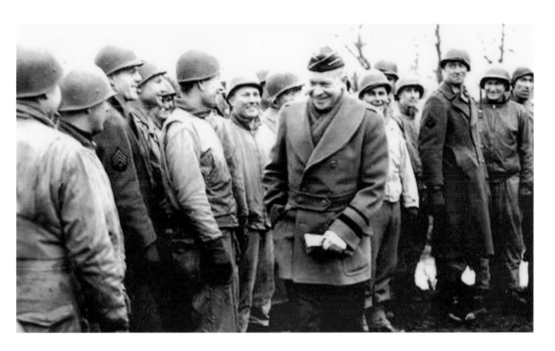

## Supreme Allied Commander

As American troops continued to build up before the invasion, the Supreme Allied Commander, General Dwight Eisenhower, visited soldiers wherever and whenever he could. As we have already seen, American forces were stationed right across the county of Wiltshire, but they were also present in huge numbers in other counties in the South and South West, notably Cornwall, Devon, Somerset, Dorset, Gloucestershire and Hampshire. In the two photographs pictured here, Eisenhower is seen with members of the 3rd Armored Division at Warminster Camp in February 1944.

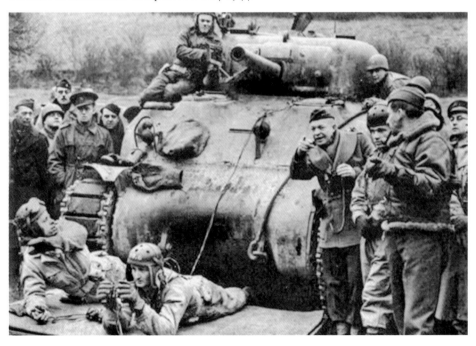

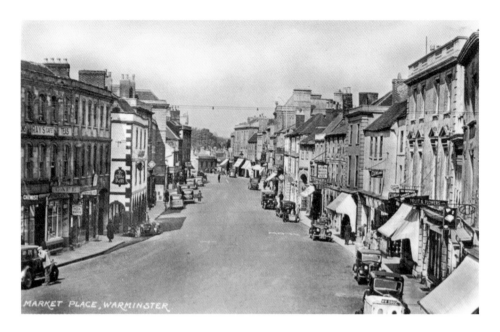

MARKET PLACE, WARMINSTER

**Bombs over Wiltshire**

Wiltshire suffered remarkably little from enemy bombing compared to its neighbours. Many bombs that did fall were leftovers that German pilots jettisoned following raids on places like Bristol. Typical of this was one that fell on the outskirts of Warminster in May 1944 causing little damage. In Market Place, seen above in the 1930s and below today, the window of Walkers Stores (now Haine and Smith) was blown out and one of the south-facing stained-glass windows of the Chapel of St Lawrence was rendered unsafe. Elsewhere, plaster fell from a farmhouse and four cows were killed.

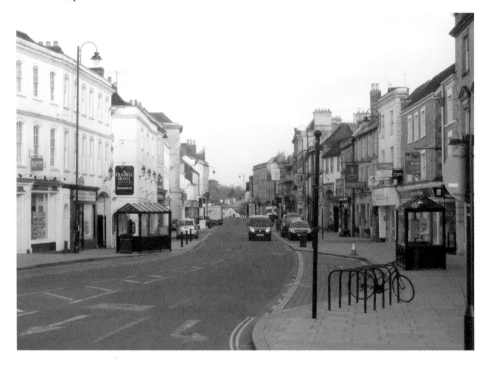

## War Work for Scouts at Westbury

Westbury was also randomly attacked, with one bomb causing damage to houses in Leigh Road. A number of properties in and around the town were taken over by the War Department, including Lodge Wood Farm, used as an ordnance supply depot, and the Scout group's headquarters in Church Street, where medical supplies were stored. The Scouts themselves relocated and were very active during the war years. For instance, they helped to meet evacuees at the railway station (*above* and *below*) and showed them, and sometimes their mothers, to their allotted homes in the parish.

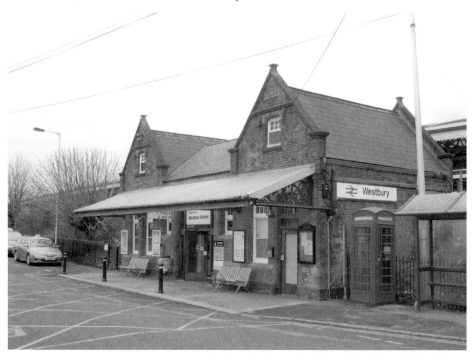

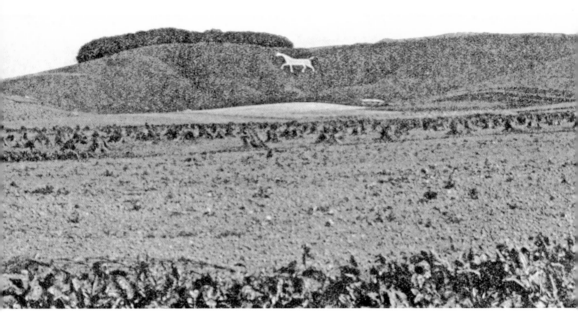

## Camouflaging the White Horses

Later in the war American troops arrived in Westbury, with the drill hall used by the 960th QM Service Company, as well as other premises. One of the area's most famous landmarks is of course the White Horse on the edge of Bratton Downs. During the war, this and many of Wiltshire's other chalk horses were covered up so that German pilots could not use them as markers. Above we see the Cherhill White Horse in the 1930s, and below as it appears now. After the war it was uncovered again, and resurfaced with chalk and cement. In 1979 a group of trainee RAF officers restored it further.

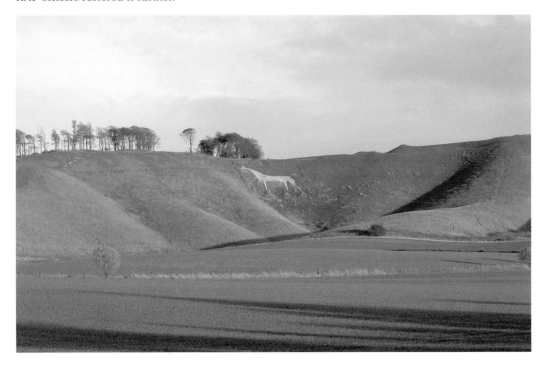

## Trowbridge as a Tank Park

Earlier we saw how Spitfires were made in Trowbridge. The town also had Army barracks on its outskirts. At the start of the war, county council headquarters moved to the newly built County Hall and their old offices in Hill Street were taken over as a canteen for the troops. Every day soldiers would be seen marching along Union Street with their mugs and plates for their meals. Other streets, such as Avenue Road seen above before the war and below today, would be lined first with British and later with American tanks, where they were both maintained and cleaned before the invasion.

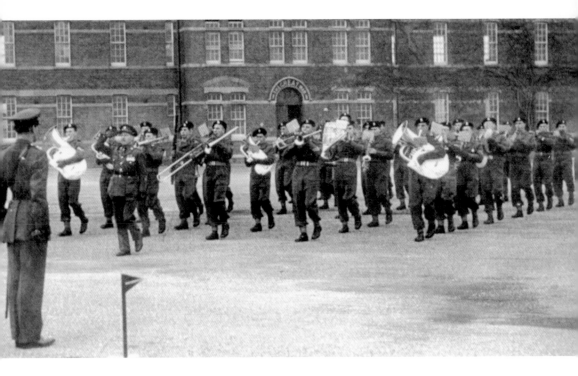

## Le Marchant Barracks and Camp

Devizes was also affected by troops as there were several military establishments around the town, such as Le Marchant Barracks seen below today and above shortly after the war as the band of the 1st Battalion The Wiltshire Regiment practised on the parade ground. There was also Le Marchant Camp, which became a prisoner of war camp. Here in December 1944 a major escape attempt was planned to coincide with the Ardennes offensive. German prisoners planned to break out, seize weapons and march on London. The plot was, however, discovered and the ringleaders moved to other camps.

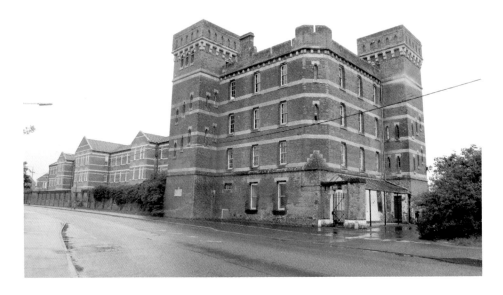

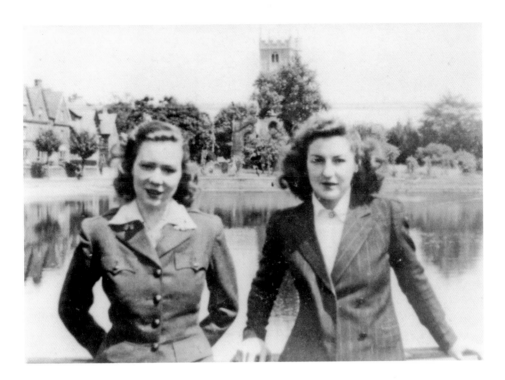

## Working Together

Other camps around Devizes included Waller Camp and Prince Maurice Camp. Many different soldiers came and went from these during the course of the war, but again it was the Americans who made the biggest impact on local people, especially the children. Above we see two ladies of the American Red Cross posing in front of St James' church and The Crammer in Devizes. Below, the same scene is pictured as it appears today. The lady on the left of the picture was Sally, the American Red Cross entertainment officer, while the other is believed to be a local lady.

# AMERICAN RED CROSS DONUT DUGOUT.

✝

## AMERICAN RED CROSS IN GT. BRITAIN.

*This is to certify that*

**Miss Elsie Caswell.**

has been accepted as Hostess
at the Devizes Service Club.

Date..7..10..44.....                    Isabella Meali.........

**The Donut Dugout**

British ladies were permitted to work in the American Red Cross clubs. The card reproduced above, for instance, was presented to Elsie Lewis (née Caswell) on appointment as a hostess at the American Red Cross Service Club in Devizes in 1944. Elsie was one of several local girls who helped out in one of these 'Donut Dugouts' as they were known. As well as doughnuts, these establishments served coffee and sandwiches and provided an alternative to pubs for those men who did not drink alcohol. Below, Elsie is pictured second from left with American servicemen and a colleague.

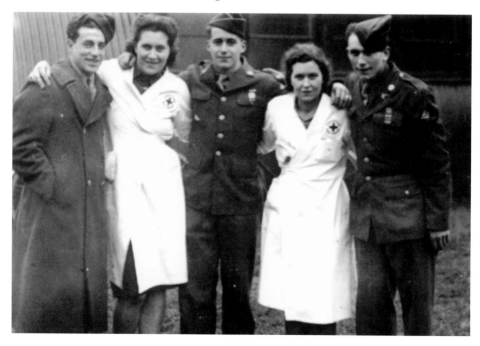

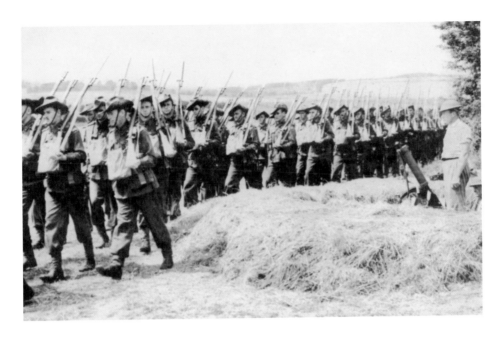

## Preparing for an Invasion

In 1940 Britain feared an invasion by the Nazis. At that time the country's ground defence was the responsibility of Home Forces, under the command of Sir Edmund Ironside, and was divided into regional commands. Wiltshire came under the jurisdiction of Southern Command led by General Sir Alan Brooke from his headquarters at Wilton House (*below*). At the height of the invasion threat Southern Command's strike force against an invasion included the Australian Imperial Forces who occupied a camp at Lopcombe Corner (*above*). Their headquarters were at nearby Amesbury Abbey.

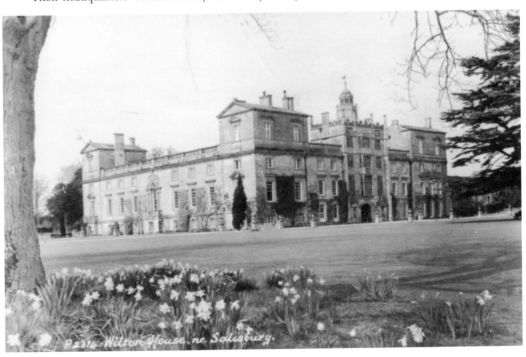

59

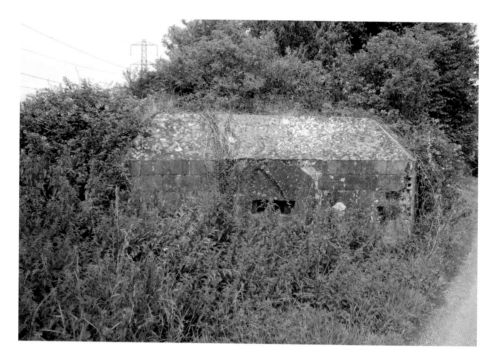

## Stop Lines

General Ironside devised a plan to protect London and the Midlands by having a line of inland defences that would hold the Germans back if they managed to secure a beachhead along the south coast. These were known as stop lines and one, the GHQ Stop Line, passed through Wiltshire, making good use of the Kennet & Avon Canal. All along its route, pillboxes would be manned by troops based in the area. Their job would be to stem the German advance until reinforcements could be brought up. Above a pillbox on the GHQ Stop Line at Bishops Cannings, and below a pillbox near Froxfield.

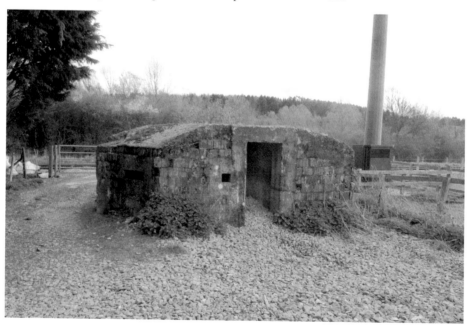

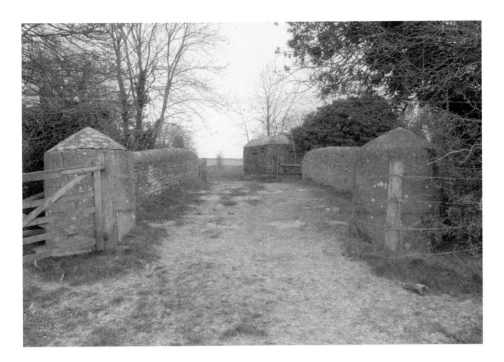

## Defended Bridges

A particularly good area to find the remains of various types of defences along the Kennet & Avon Canal is around Honeystreet near Alton Barnes. Not only will you discover numerous pillboxes, but also other things such as the defended bridge pictured above. As well as the obvious gun emplacement at the far end you will note the slots on the bridge itself, into which sections of railway line could be hoisted to help bar the way. There is also a series of anti-tank obstacles around the crossing. The bridge below still boasts the remnants of a roadblock that was established here at the time.

## Marlborough Expects

Some unusual defences from the war years are still visible in Marlborough. Above are the remains of a mini pillbox in Kingsbury Street designed to help defend the town from attack from the north. The single embrasure has now been filled in, so to passers-by it simply looks like a strange block of concrete. The image below shows a flint wall in High Street. Look carefully and you will see a filled-in doorway. In the war years there was a reinforced door here with a loophole in it, through which the Marlborough Home Guard would have targeted enemy troops advancing along the street.

## The Home Guard

General Brooke, pictured on the right during a Southern Command training exercise, could also rely on the Local Defence Volunteers to supplement his force, which Winston Churchill renamed the Home Guard in August 1940. Below is the Chitterne contingent in front of Manor Farm. In the front row are the local Army cadets who were often employed as messengers, or to play the part of the enemy during exercises. The Home Guard was arranged on a territorial basis with local recruits badged to the Wiltshire Regiment. The county raised thirteen battalions.

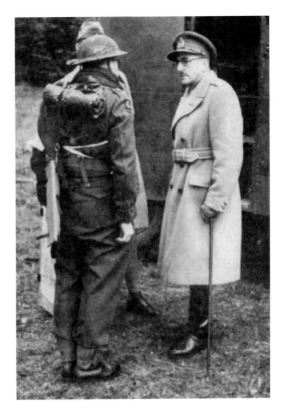

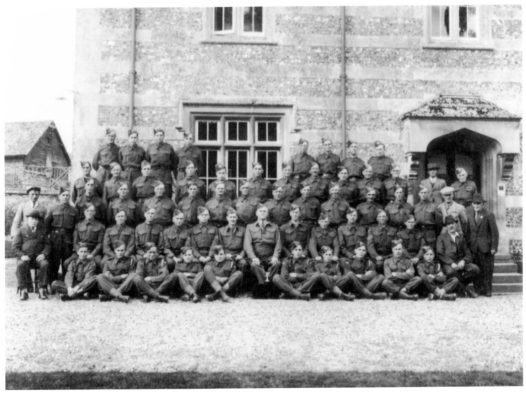

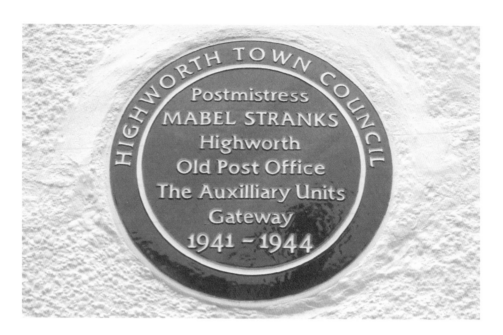

## Auxiliary Units

There were also specialist bodies known as Auxiliary Units, who were trained to work behind enemy lines in the event of an invasion, operating as saboteurs from underground bases. They were trained in the grounds of Coleshill House near Highworth, and recruits arriving for the first time had no idea where they were going. They were simply instructed to present themselves to Mabel Stranks, the postmistress at Highworth Post Office (*above* and *below*) and repeat a password. If she was satisfied that they were not enemy spies, she would arrange for a car to arrive and take them to Coleshill House.

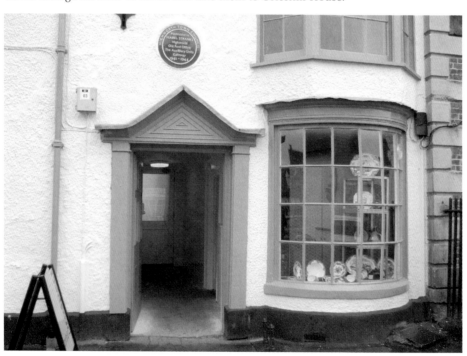

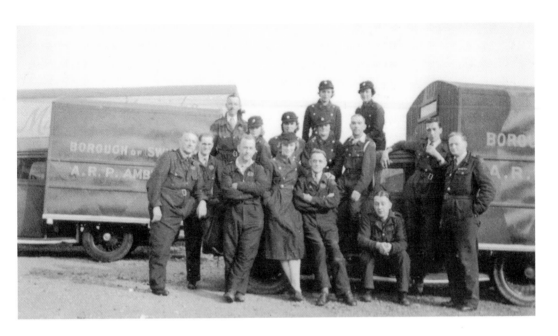

## Air Raid Precautions

But the Home Guard was only one of a number of organisations to which people flocked at their county's greatest hour of need, with everyone keen to do their bit. Another uniquely wartime occupation was that of Air Raid Precautions Warden, whose job was to help protect the public from air attacks by enforcing the blackout, or advising on the use of gas masks, air-raid shelters and other protective equipment. Above and below we see members of Swindon's ARP ambulance contingent. Other people might have been first-aid volunteers, auxiliary firemen or members of the Observer Corps.

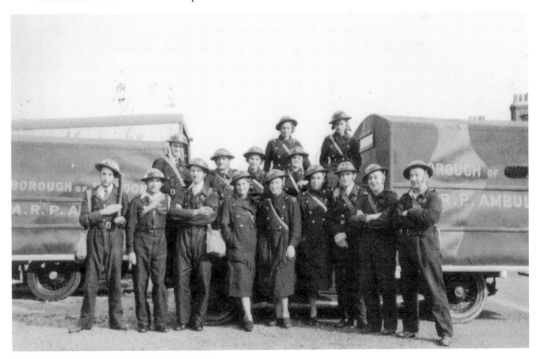

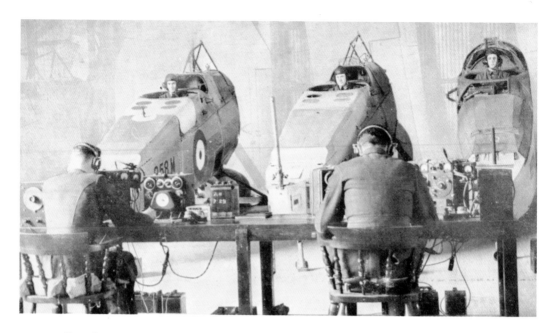

## Radio School

A short distance east of Calne is the site of the former RAF Yatesbury, which was the location of No. 2 Radio School, where the theory of wireless and Morse code was taught on the ground (*above*), while aerial training was given in De Havilland Dominie and Percival Proctor aircraft. It was also here, on another part of the site, that students were introduced to one of Britain's best-kept secrets, Radio Direction Finding, which of course was later known as radar. Below is a monument at the site of No. 45 Satellite Landing Ground, Townsend, used by No. 2 Radio School, among others.

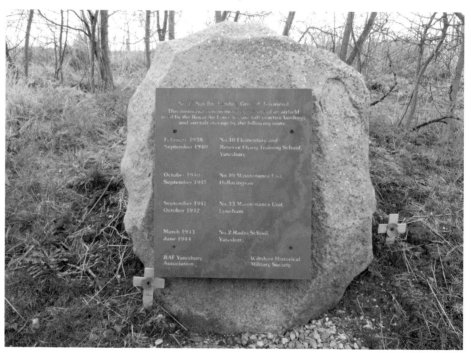

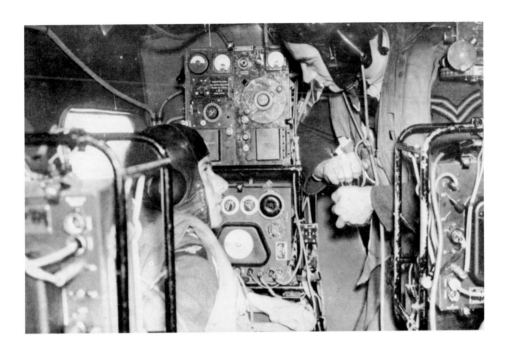

## Radio Direction Finding

In the photograph above, a maze of dials confronts a trainee radio operator under instruction in an aircraft at Yatesbury. But after its success during the Battle of Britain, more and more emphasis was placed on the importance of airborne radar. Two years later in 1942, an RDF School opened at Yatesbury and was very shortly afterwards renamed No. 9 Radio School, presumably to conceal its true purpose from the enemy. All aspects of radar were taught here, from the role of ground controllers to airborne interception and air-to-surface vessel interception. Below are the remains at Yatesbury today.

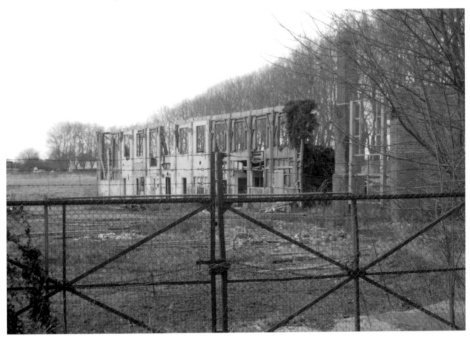

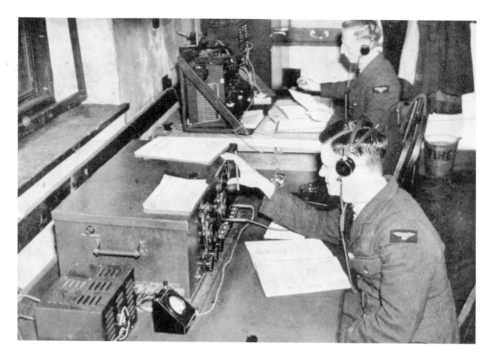

## Signals

There was an ever-increasing demand for radio and radar operators in all RAF commands, which in time led to the formation of No. 2 Signals School at Yatesbury and No. 3 Signals School at nearby Compton Bassett. Today many of the old buildings are still in evidence, but there is very little to indicate just how important this corner of Wiltshire, and indeed radar itself, was to the overall Allied victory against the Axis. Above students are seen practising with signals equipment, and below are further wartime buildings at the site of the former RAF Yatesbury.

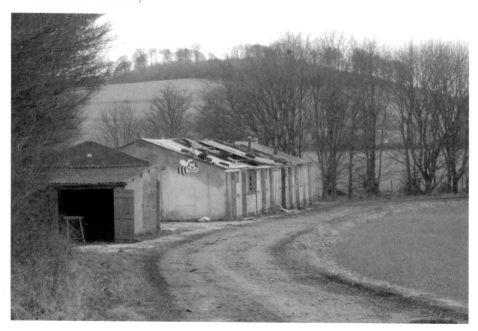

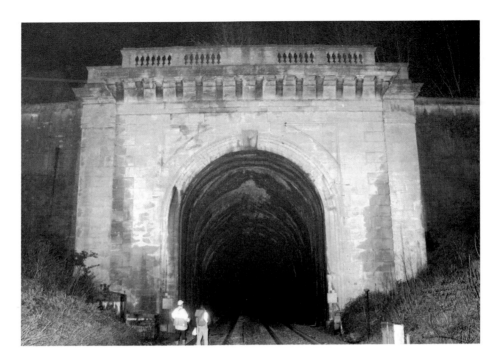

## Box Tunnel

Another Wiltshire landmark is Box Tunnel (*above*), built under the direction of Isambard Kingdom Brunel and opened in 1841 to take the Great Western Railway through Box Hill between Bath and Chippenham. During the war, it was also the entrance to a secret world. For around 200 years this entire area had been excavated for Bath stone, which left a labyrinth of underground tunnels and chambers beneath the Wiltshire countryside (*below*). In the 1930s the War Office began to see their potential and over the coming years they were given up for a number of different uses.

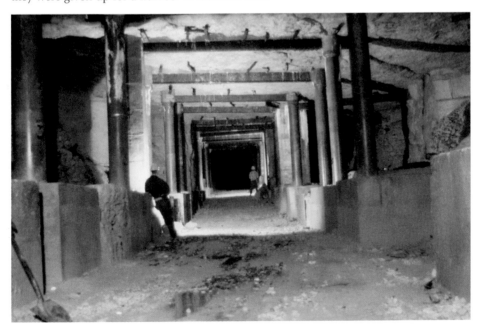

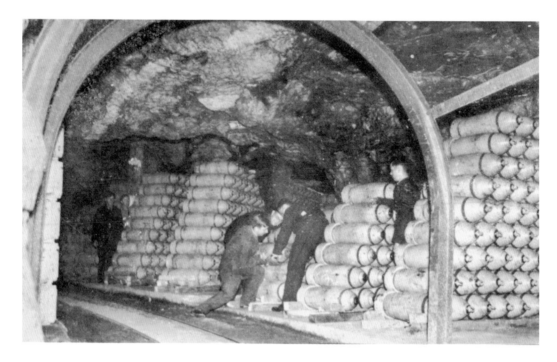

## Central Ammunition Depot

One use was the storage of ammunition and bombs, which led to the creation of the Central Ammunition Depot (*above*) where over 300,000 tons of ordnance were ensconced in bomb-proof magazines 100 feet below ground. The depot was split between a number of different sites, the largest being Tunnel Quarry, which offered 44 acres of storage space. It was also directly connected to the GWR main line by a branch that entered the quarry through a small tunnel at the side of the eastern portal of Box Tunnel (*below*) and led to a loading platform half a mile underground.

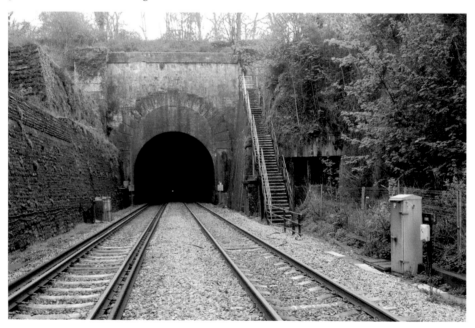

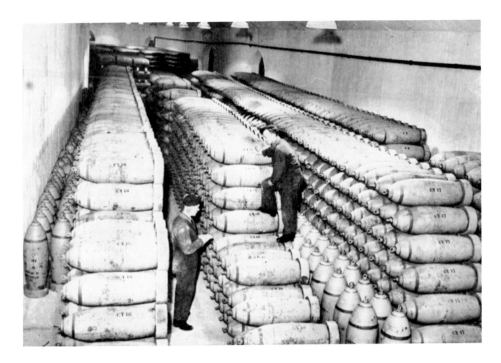

### Thingley Junction

Before the quarry could be used for storing explosives it had to be cleared of some 2 million tons of debris, which was conveyed on standard gauge tipping trucks to Thingley Junction, where it was used as landfill to build up an area that became the depot's assembly sidings, seen below today. Here the ordnance would arrive from the factories before being transported to the quarries for storage (*above*). Then later, as and when needed, it would be taken back to the sidings to be prepared, before being dispatched to the end users, who ranged from bomber squadrons to artillery units.

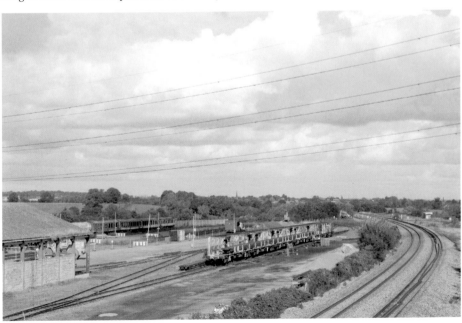

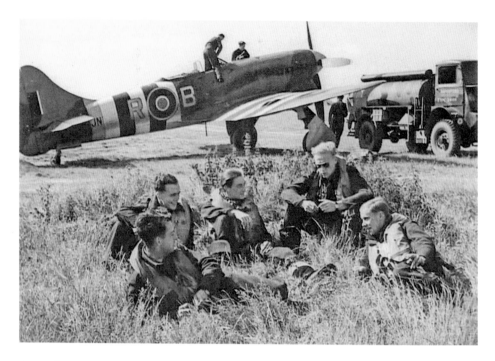

### An Underground Aircraft Factory

At Spring Quarry the Ministry of Aircraft Production established an underground factory where the Bristol Aeroplane Company moved some of its aero-engine production following the bombing of its facility at Filton. From 1943 the Bristol Centaurus engine, which was fitted into the Hawker Tempest fighter bomber (*above*), was made here. Copenacre Quarry was converted into a naval stores depot and was in use from the 1940s to the 1990s. Below we see a telephone box and the manager's office in the background. It has since become a dumping ground for the adjoining Hartham Quarry.

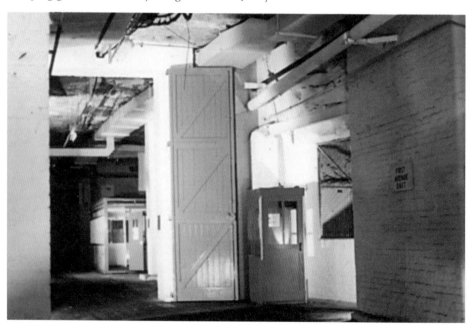

## No. 10 Group Fighter Command

Among other facilities in this vast underground city were locomotive repair shops (*right*) and a telephone exchange known as South West Control. At Brown's Quarry the emergency headquarters of No. 10 Group Fighter Command were established, initially known as RAF Box and later RAF Rudloe Manor. To defend British airspace, Fighter Command divided Britain into four regions. No. 10 Group guarded the west of England and south Wales, and RAF Rudloe Manor housed the operations room needed to direct the movement of aircraft under its control. Below is a picture of Rudloe Manor itself.

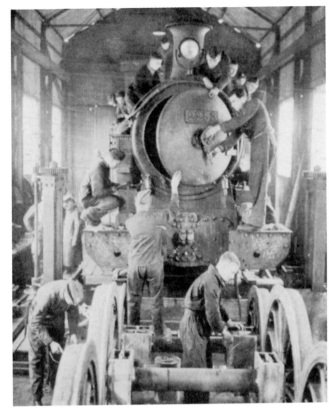

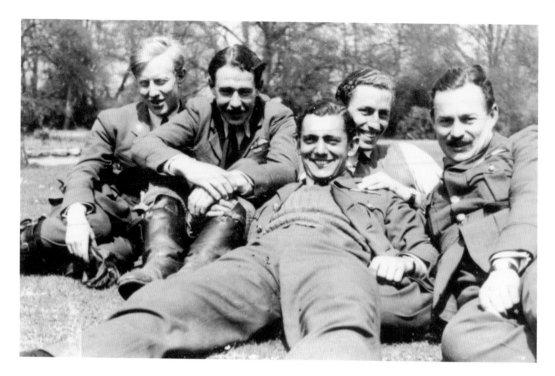

## Lending a Helping Hand

In 1940, aircraft from No. 10 Group even operated over London, reinforcing their neighbours in No. 11 Group, who bore the brunt of the air fighting, but they still received their instructions directly from their controller in Box. Squadrons commanded from Box were located at airfields all over the West Country, including RAF Colerne. Occupants here ranged from 501 Squadron (*above*) flying Hurricanes, to 616 Squadron equipped with the Gloster Meteor. Below is part of a decoy at West Littleton in south Gloucestershire constructed to attract enemy bombers away from the airfield.

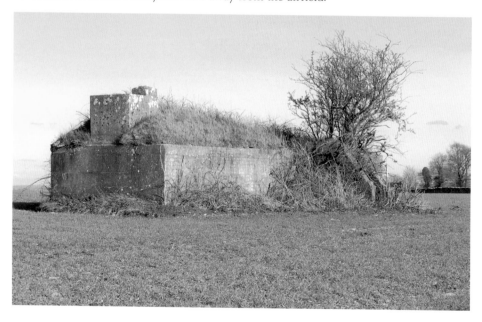

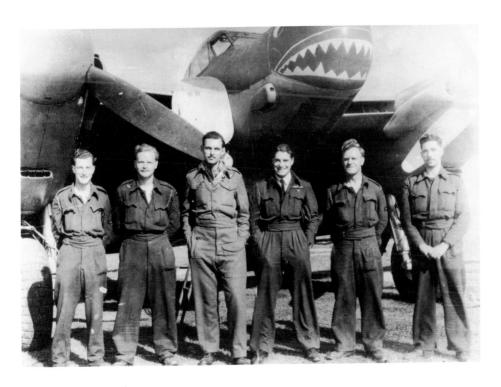

## The Evidence Remains

In the photograph above we see officers and groundcrew of No. 604 Squadron at Colerne in August 1944 standing in front of a Mosquito XIII. The officers of No. 10 Group were accommodated in Rudloe Manor itself, while airmen were housed in tents until permanent buildings were provided for their use. Some of the area around Corsham remains in military hands today, but there is still much evidence of its varied wartime uses. The remains seen below are one of several ruined military buildings that can now be seen near Thickwood, close to the perimeter of Colerne airfield.

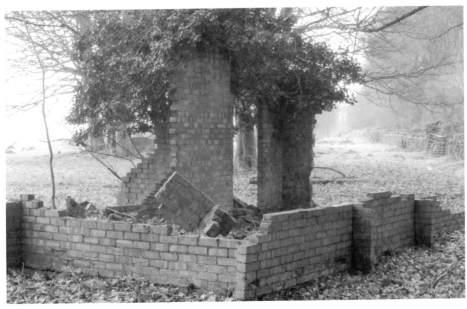

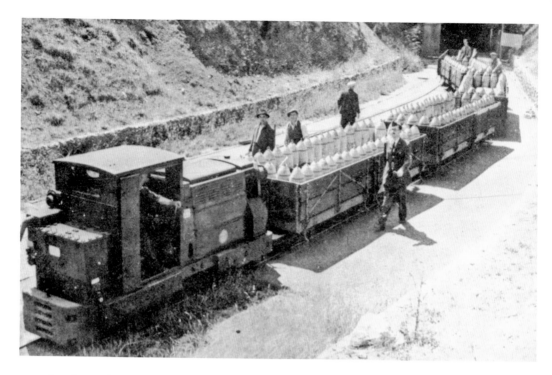

### Bombs at Chilmark

As well as the quarries around Corsham, there were many more ammunition sites in the county of Wiltshire. To the south of Chilmark for instance there was another important ammunition and bomb depot established in quarries that had been purchased by the Air Ministry in 1936 to store ordnance for RAF use. When required for deployment to strategic airfields the bombs would be taken from an old mine on the depot's narrow gauge railway (*above*) to a rail transfer station at Ham Cross and then on to the main line at Dinton. Below we see some of the surviving buildings at the depot.

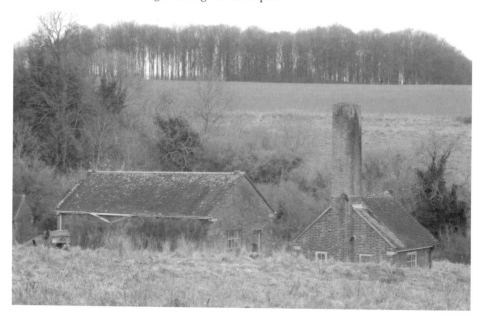

## Aviation Crash Sites

Wiltshire was strewn with airfields, and other reminders of the war years found throughout the county are memorials dedicated to those who perished here at the time. Here are two examples, but there are many more. The one above is near Honeystreet and commemorates the crew of an Albemarle bomber that crashed here in October 1944 while flying from RAF Keevil. The one below is at Alton Barnes and can be found attached to the last remaining air-raid shelter at the former airfield. The memorial is dedicated to five listed individuals who lost their lives here while training.

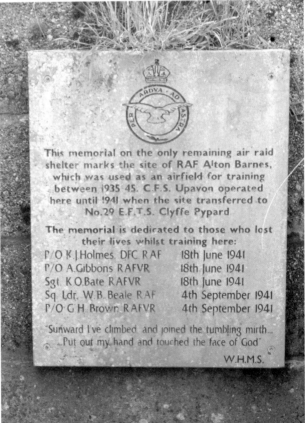

This memorial on the only remaining air raid shelter marks the site of RAF Alton Barnes, which was used as an airfield for training between 1935-45. C.F.S. Upavon operated here until 1941 when the site transferred to No. 29 E.F.T.S. Clyffe Pypard

The memorial is dedicated to those who lost their lives whilst training here:

| | |
|---|---|
| P/O K.J.Holmes. DFC. RAF | 18th June 1941 |
| P/O A.Gibbons RAFVR | 18th June 1941 |
| Sgt. K.O.Bate RAFVR | 18th June 1941 |
| Sq. Ldr. W.B. Beale RAF | 4th September 1941 |
| P/O G.H. Brown RAFVR | 4th September 1941 |

"Sunward I've climbed and joined the tumbling mirth...
...Put out my hand and touched the face of God"

W.H.M.S.

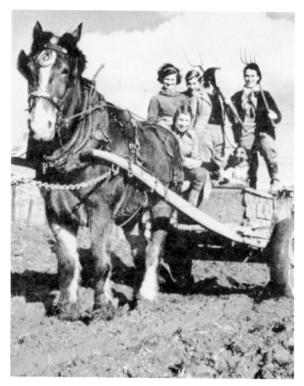

### Bombing the Harvest

Chippenham was the home of the Westinghouse Brake and Signal Company, which made braking and signalling equipment for the railways in its factory just to the north of the railway station, seen below. In 1939 the engineering, sales and publicity departments were also moved here from London. German photographs from the time show the complex as a potential target, although it was never attacked. The main bombing around Chippenham involved the attempted destruction of harvest fields in the summer months such as those worked by the Women's Land Army (*left*).

## Evacuees in Lacock

During the Second World War, Lacock Abbey was the home of Matilda Theresa Talbot. At the time she allowed the house to be used by evacuee mothers and their children from Shepherd's Bush in London. As well as these, eighty-five children from a London primary school were relocated here. Six different units of British troops and later American troops also enjoyed the grand surroundings. In 1944 Matilda presented Lacock Abbey, the village and 284 acres of grounds to the National Trust. Above and below are photographs of Lacock Village from 1937.

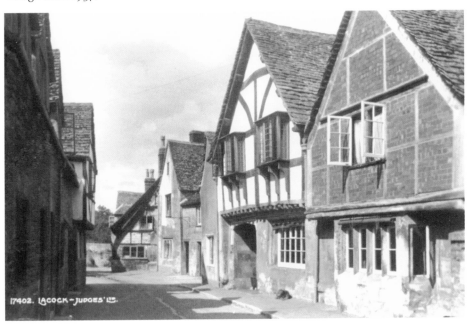

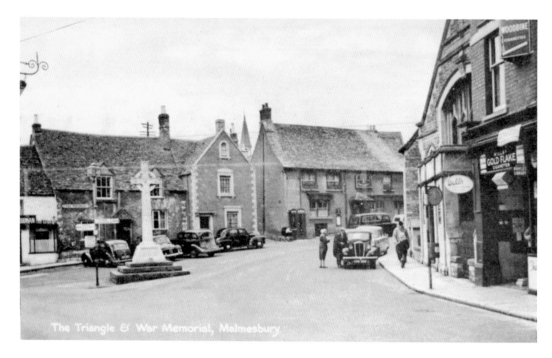

The Triangle & War Memorial, Malmesbury

### Secret Work at Malmesbury

Above and below we see Malmesbury, a town where many residents worked on a secret project without even knowing it. In 1939 the electrical appliances division of E. K. Cole Ltd was instructed by the Air Ministry to establish a factory to make radio equipment at Cowbridge House. Unknown to the people of the town, or the 1,000 people working at the factory, they were actually working on radar equipment. Secrecy was taken seriously and regular reconnaissance flights over the site by the RAF checked that, from the air, Cowbridge House looked like nothing more than a large country estate.

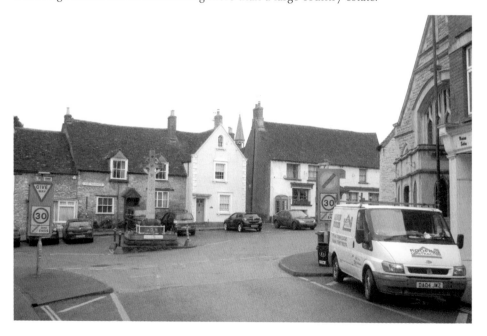

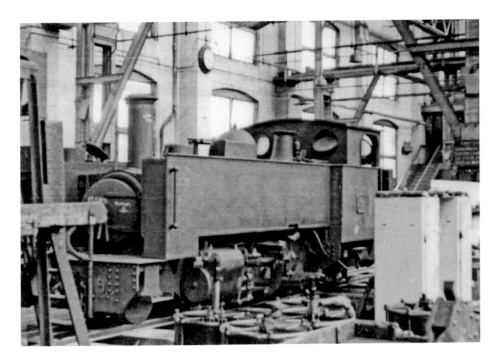

## A Manufacturing Town

Swindon became famous for the manufacture of railways, and because of the highly skilled workforce that already lived here the Ministry of Aircraft Production saw it as an ideal place to build aeroplanes for the war effort. Above we see a steam railway engine being repaired inside the vast 'A' Shop at the Great Western Railway works. Driving past Swindon now on the A419 you will see Honda's massive car-manufacturing plant at South Marston (*below*). This purpose-built factory was constructed in the 1980s when the old Vickers aircraft plant that stood here previously was pulled down.

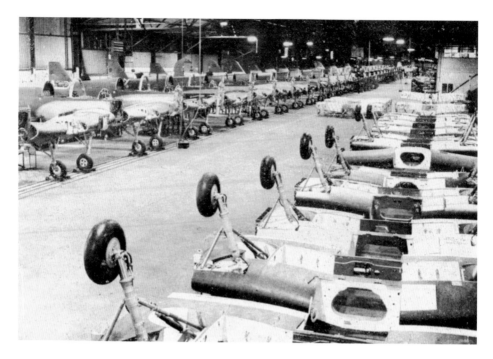

## Miles Aircraft

The original factory at South Marston was built in 1940 to produce aircraft designed by Frank Miles, notably the Miles Master. Most of the staff were transferred from the Great Western Railway works where they worked on the manufacture of railway carriages. Below is a picture of former housing for Great Western Railway employees in the town. Manufacture of aircraft was spread over several sites as a safeguard against Nazi bombing, so smaller units were also employed nearby at Blunsdon and Sevenhampton. Above we see Miles aircraft on the production line at South Marston.

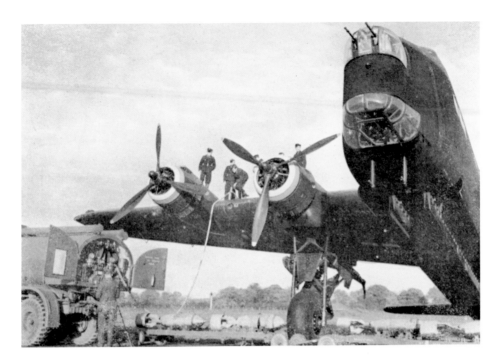

## Stirling Production in Swindon

In August 1940, after the Luftwaffe bombed the Short Brothers factories in Belfast and Rochester, where they were building the new Short Stirling bomber (*above*), it was decided to bring some of that production work to Wiltshire. However, because of ongoing commitments, nowhere was big enough to take on the whole enterprise, so the work was shared among various sites, including the Great Western Railway works where the wings were constructed. The picture below shows a repaired engine standing outside the railway works in 1950, now the home of the town's Steam Museum.

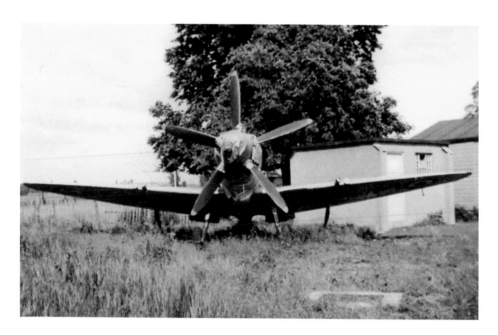

## Spitfire Production in Swindon

In April 1943 South Marston was taken over by Supermarine as a shadow factory. From then until the end of the war the site was mainly employed in the manufacture of Spitfires. The first variant to be built entirely at South Marston was the Spitfire 21 (*above*), which had a Rolls-Royce Griffon engine, a five-bladed propeller and four 20-mm cannons. The first delivery was made to the RAF in December 1943. The photograph below is of the Spitfire Café, one of several aeronautical references in South Marston that are all that now remind us of the proud industry that once flourished here.

## Commander Bond

Also produced at South Marston was the Seafire, the Fleet Air Arm's version of the Mark 21. The last aircraft to be made here was completed in January 1949. While visiting Sevenhampton, it is worth making a trip to the village churchyard to see the grave of James Bond creator Ian Fleming. During the war Fleming worked for British Military Intelligence and became a Commander, the same rank as the fictional hero in his novels. By coincidence, his brother Peter Fleming had been involved with the training programmes for auxiliers at Coleshill House and Hannington Hall.

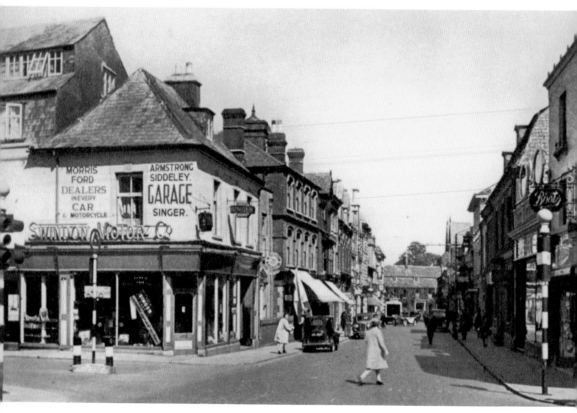

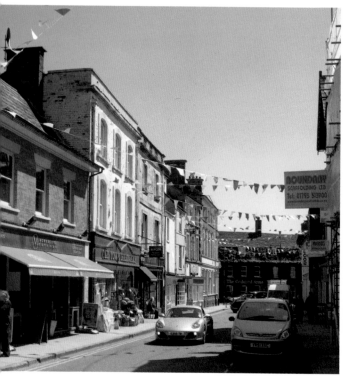

## Bombs over Swindon

In the photograph above we see Wood Street in Swindon in the 1940s and below as it appears today. At the start of the war the people of the town were warned that they were likely to come under heavy air attack because of the railway works, which at that time was one of the biggest industrial complexes in the world. But this was not to be the case and Swindon, similar to the rest of the county, suffered very little from bomb damage. The first bombs fell harmlessly on 14 August 1940 near Wroughton airfield, with nine more at Stratton the next day and others in the weeks that followed.

### Swindon's First Fatalities

The first fatalities in Swindon happened on 20 October 1940 when bombs fell on Graham Street, York Road and Rosebery Street, killing ten people. Swindon would not be targeted again until 19 December, when a raid caused one death in Beatrice Street. Although people feared the worst, the bombers did not return again until 1942 and even then the scale of the bombing remained low compared to other towns and cities of similar size and importance. Above we have another Swindon view from the 1940s, this time of Bridge Street, while in the photograph below a freight train is seen passing Swindon station.

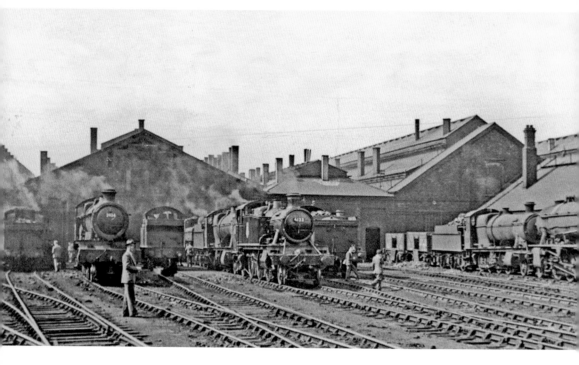

### Swindon's Last Fatalities

In 1942, three separate attacks raised the death toll to forty-eight. On 27 July the Great Western Railway works received their first and only attack, which caused a fire in a gasholder. Above and below are further contemporary views of the railway depot and works in Swindon, respectively. On 17 August came the worst night of bombing the town would ever see. Two separate incidents caused nineteen deaths in Ferndale Road and another ten in Kembrey Street. On 29 August eight people were killed in Drove Road, the final civilian casualties in the town.

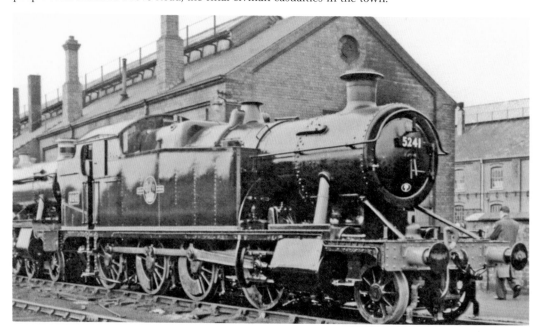

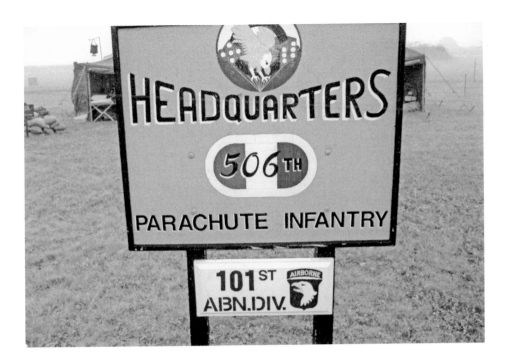

### Paratroopers in the Kennet Valley

The final part of our journey takes us to the Kennet Valley at the eastern edge of the county. In 1943 some of the picturesque villages in this area became home to elements of the American 101st Airborne Division as it prepared to take part in the invasion. In particular, the 506th Parachute Infantry Regiment was accommodated at several camps in the Marlborough area. Much of the regiment was based at Ramsbury (*below*), where they took part in pre-invasion manoeuvres in local fields and woods. Above we see the insignia of the 506th Parachute Infantry Regiment.

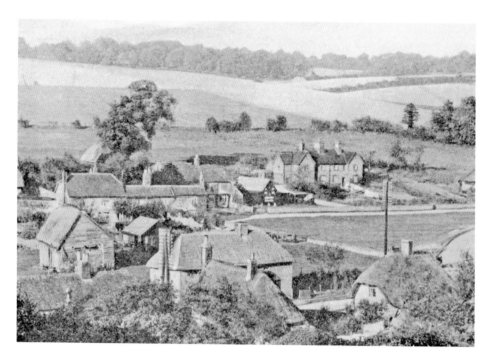

## Village Life

The nearby village of Aldbourne became the home of the battalion's Easy Company, who were made famous in the book by Stephen Ambrose, *Band of Brothers*. Easy Company would camp out in the woods for several days and nights at a time, often using live ammunition. There was a ready supply of ammunition for these manoeuvres, as the War Department had established a large ordnance depot in the Savernake Forest, a few miles to the south. Further troops of the 506th Parachute Infantry Regiment were camped at the village of Froxfield, seen above in the 1940s and below today.

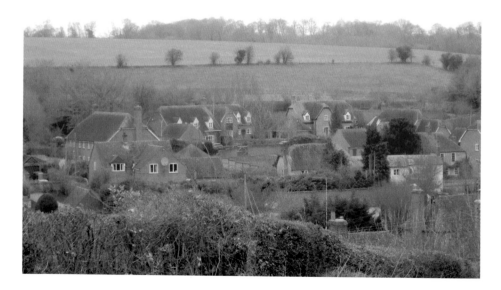

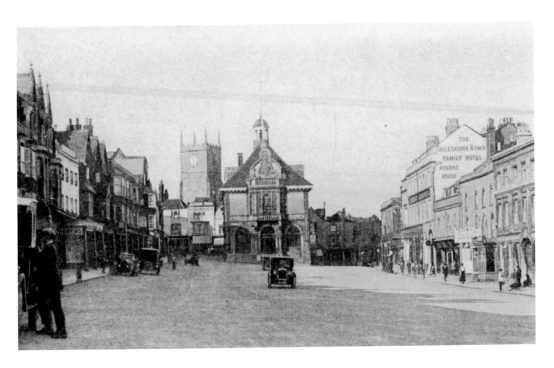

### Regimental Headquarters

Part of Littlecote House at Chilton Foliat was taken over as regimental headquarters. The house provided office space and sleeping quarters for officers of the regiment, with the best rooms allocated to Colonel Robert F. Sink, the commanding officer, and Lieutenant Colonel Charles H. Chase, his executive officer. The colonel is said to have used the library of the house as his office. And of course the hospitality of Marlborough itself, with its beautiful main street seen above in the 1930s and below today, was an obvious draw for American soldiers when they were off duty.

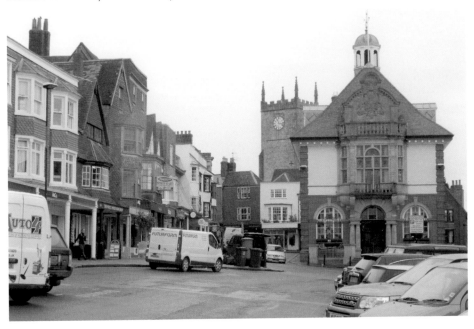

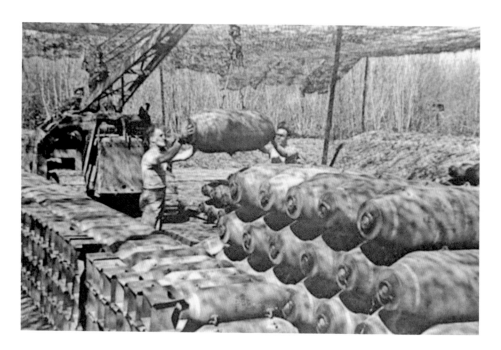

## Ammunition Storage in the Savernake Forest

Below are some of the remains that exist in the Savernake Forest of the huge ammunition depot that was located here, used by both the British and the Americans. It stored all types of ordnance from small arms ammunition to bombs and chemical weapons. Fire-fighting exercises were held regularly, and following one it was decided that a number of water storage tanks should be installed throughout the forest, built of reinforced concrete that could hold in excess of 10,000 gallons. In the photograph above we see Americans unloading bombs in a woodland setting, possibly the Savernake.

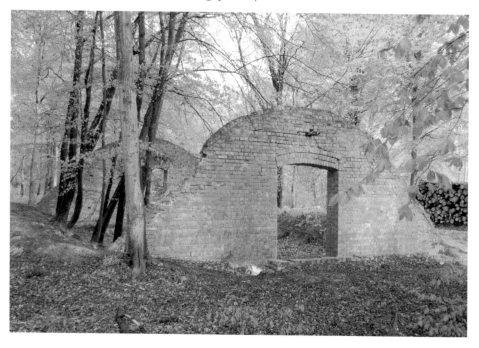

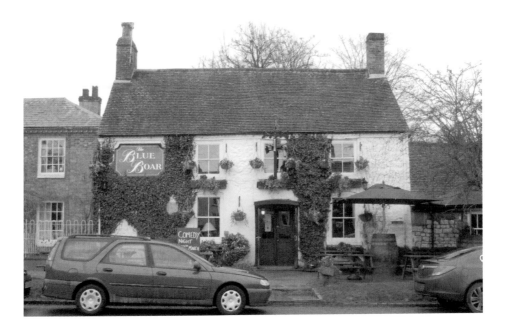

## A Time to Relax

During their stay in the village of Aldbourne, the Blue Boar Inn (*above*) was used as Easy Company's officers' mess and as such was off limits to the enlisted men, although the owners did allow them in for a drink when no officers were around. There were stables behind the pub where some of the men were billeted. The basement of The Crown (*below*) was used as their command post. The main reason why the 506th was based in the villages around Marlborough was to be close to the airfield at Ramsbury, as it would be from here that they would leave for the D-Day drop.

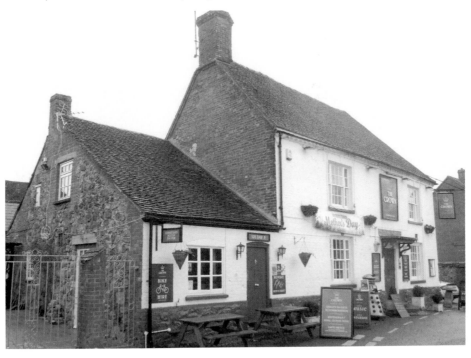

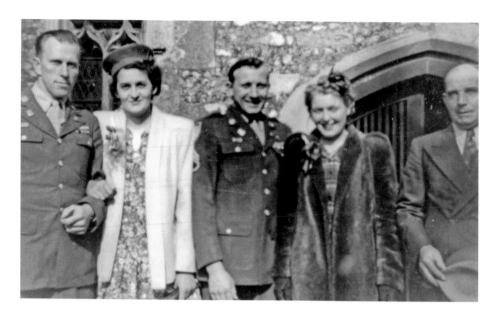

## Lasting Ties

When the 101st Airborne Division arrived at Froxfield, Joan Mundy was working on a local farm with the Women's Land Army. She fell in love with a GI called Don Hetrick and before going to Normandy he asked her to marry him. Don had to get special permission from his commanding officer and, although Joan's parents had initial concerns, the couple would eventually marry at St Michael's church in Little Bedwyn, her home village, on 12 March 1945 after his return from France. They are seen on the left of the above picture outside the church, the porch of which is seen below as it looks today.

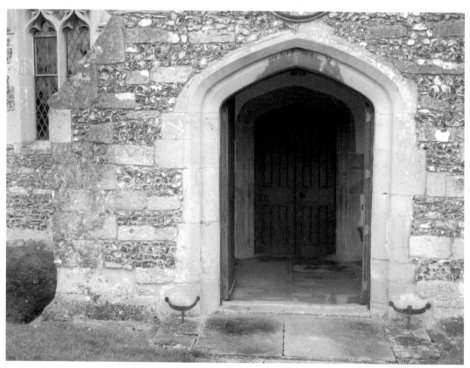

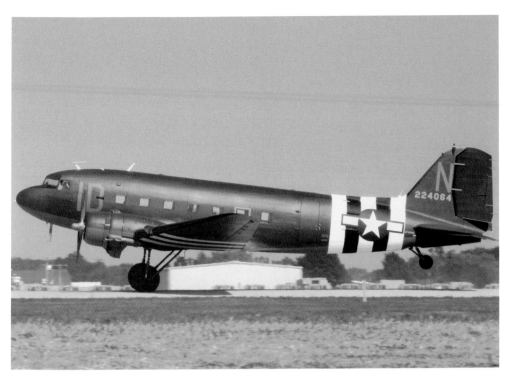

**Dakotas over Wiltshire**

The airfield at Ramsbury was built as a training base, little of which now survives, for RAF Bomber Command and had three concrete runways. In November 1943 it became Station 469 of the 9th United States Army Air Force and the 437th Troop Carrier Group arrived to work alongside the 101st in preparation for D-Day. Leading up to the invasion, they trained in dropping paratroopers from Douglas C-47 Dakota Skytrains and towing Horsa gliders. Above is a Dakota painted in its invasion markings, while below we see some of the remaining concrete at the former Ramsbury airfield today.

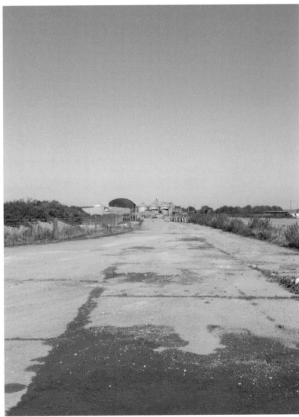

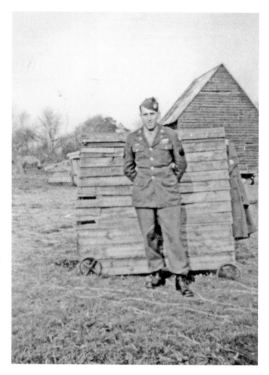

## Final Operations from Wiltshire

On D-Day itself, aircraft from Ramsbury would take part in the initial airborne assault; they would also participate during Operation *Market Garden* in September 1944 and the Battle of the Bulge just before Christmas 1944, which would be the final major operation mounted from anywhere in Wiltshire during the conflict. Above, Don Hetrick can be seen down on a Wiltshire farm in his 101st Airborne Division uniform, while the monument pictured below near Axford is dedicated to all members of the 437th Troop Carrier Group who were stationed at Ramsbury airfield during the war.

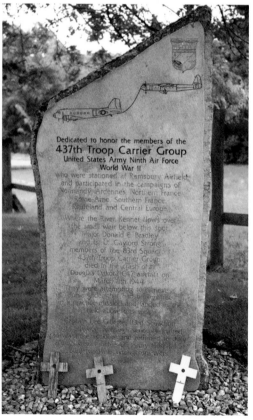

Dedicated to honor the members of the
**437th Troop Carrier Group**
United States Army Ninth Air Force
World War II
who were stationed at Ramsbury Airfield
and participated in the campaigns of
Normandy, Ardennes, Northern France,
Rome-Arno, Southern France,
Rhineland and Central Europe